The Sequential Artists Workshop
Guide to Creating Professional Comic Strips

by Tom Hart

Alternative Comics

Published by Alternative Comics
21607B Stevens Creek Blvd.
Cupertino, California 95014
IndyWorld.com
Marc Arsenault, General Manager
David Nuss, Associate Publisher
Laura Susong, Assistant Editor
Ann Xu, Production
Printed in the United States of America
ISBN: 978-1-93446-089-4

The Sequential Artists Workshop
PO Box 13077
Gainesville, FL 32604-1077
www.sequentialartistsworkshop.org

Copyrights and credits:
Images of *Ali's House*: copyright © 2016 Tom Hart and Margo Dabaie
Images of *Edge City*: copyright © 2016 Terry and Patty Laban
Images of *Ha Ha Constance Planck*: copyright © 2016 Hilary Allison
Images of *Narbonic*: copyright © 2016 Shaenon Garrity
Images of *Tina's Groove*: copyright © 2016 Rina Piccolo
Images of *Velia, Dear*: copyright © 2016 Rina Piccolo
Buz Sawyer copyright Hearst Holdings, Inc.
Some drawings by Stephanie Mannheim: stephaniemannheim.com

SAW mascots: Female: copyright © 2016 Vanessa Davis; Male: copyright © 2016 Trevor Alixopolous

Images of Thimble Theater believed to be copyright-free. "Popeye" is a registered trademark of Hearst Holdings, Inc.

The Sequential Artists Workshop

Guide to Creating Professional Comic Strips

Contents

Introduction by Tom Hart

Welcome! So glad you could make it. Welcome to *The Sequential Artists Workshop's Guide to Creating Professional Comic Strips.* The Sequential Artists Workshop (SAW) was formed in 2010 as a school and resource-house for cartoonists of all kinds everywhere. We teach workshops and year-long classes in Gainesville, Florida, and also offer online tutoring and workshops, and some books and other resources and courses like this one. See the final page for more info on how to attend SAW, or download our materials or sign up for our online classes.

This is a book of instruction, suggestions, ideas and parameters and comes from years of my own practice and dedication to comics strips. Inside, you'll find hints and tricks and rules (and some rule-breaking) but also stories about my own wrestling with the important issues of creating ideas, characters, of writing, drawing, and selling a comic strip. There's also interviews with editors and other professionals, side discussions about related issues, as well an overview and historic examples.

In addition, for those who have signed up for the full course, there are exercises to try and to e-mail or send back to SAW for review and critique. See the exercise pages or the last page for more about that.

The main concern of this book is with newspaper strips, but in 2011, we have to face reality and realize that newspapers strips is a shrinking industry. Comic strips may always be with us, and so may the major comic strip syndicates, but newspapers and the strips inside are undergoing major changes and for the most part, their numbers are dwindling. (More about all of this in detail and anecdote form later.)

So we will also examine the ideas and possibilities of weekly comics, web comics, and self-published strips, etc. as ways to get your vision out there. The details and professional ideas inside this book relate to all these fields in the same way (with the exception of the specific newspapers size and scale issues).

My own experience with strip comics dates back to my earliest memories, of tracing pictures from *Peanuts* from the newspapers at age 7. More than that, I looked to *Peanuts* and other strips as a way to behave and react to the world. Cartoon characters made more sense to me than real people did. I think this is true of most people who get into making comic strips.

Since those early days, I have drawn professional comics and graphic novels for 20 years, strip comics for around 8 years, spending 3 of those in the mainstream paper market. The stories I'll share inside are the good, the bad, and the ugly of professional comic strip making and selling.

Specifically from my history, I'll share samples from and stories about *Ali's House*, a comic strip that I co-created with Margo Dabaie

and that was syndicated by King Features Syndicate in 2008, as well as from my self-syndicated series, *Hutch Owen* that ran daily for 2 years in newspapers in Boston and New York.

Despite the bad and the ugly, the reason people want to make comic strips is the *good*: the joy in drawing funny or exciting stories, the ability to comment on and connect with the world through a series of drawn, fake personalities and their mini-adventures. Comic strip creators often have a love of drawing—of making drawings that make the artists themselves smile or jump out of their seats.

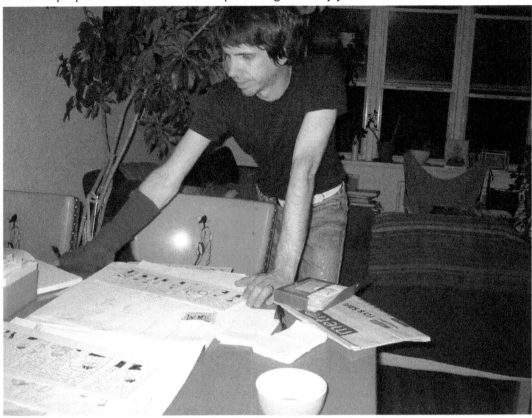

The odds are that if you want to create comic strips, you feel you've got something to share with the world that is somehow different than other stuff you see out there. This book is dedicated to getting you to find that stuff you want to share, and guiding you to sharing it in the clearest way possible.

The author on a deadline. Before him, the accoutrements of the trade: Bristol board, pens, paper, index cards full of ideas, coffee, newspaper, and drawing glove (to keep drawings from smudging...)

Let's get started!

Technical Stuff

The first thing to notice is that newspaper comic strips are small. Really small. (This breaks the heart of most professional cartoonists.) Open up your local daily newspaper. Chances are you'll see the strips are no larger than 6 or 7 inches wide, and usually less than 2 inches tall. (FIG. 1.) It's not a lot of space.

FIG. 1 The average size of a printed comic strip.

Comic strips as a simple form—meaning if they're not attached to newspapers—have a lot of flexibility: you can change width, height, break the boundaries a lot more, alter the format now and then, etc. But still, it is a compact medium, meaning it offers its material up in little chunks. And it tends to be a frequent medium, meaning that something new is read and created often.

This definition of comic strips seems to be consistent whether we're working within newspapers or outside of them: they're frequent, compact chunks of cartooning.

So we'll start with newspaper parameters, realizing that this is a rule for the syndicates and newspapers, but only a jumping off point for people paving their own way.

The Ratio

The daily newspaper comic strip ratio is 1 x 3.2, meaning 1 unit tall and 3.2 units wide. See FIG. 2.

FIG 2.The ratio of this box is 1 unit tall by 3.2 units long.

Your strips must be at this exact ratio, but can be drawn any size, so long as they can scale down to this size (and still be legible!) You can decide on a size by multiplication (you could draw 4 times that size, at 4"x 12.8" for instance), or you could use the scaling method. Utilizing

FIG 3. The scaling method of finding the correct ratio.

FIG. 4.

the scaling method, you merely need to draw a diagonal from on corner to the other of your original box, extend it beyond your original box and drop a horizontal and vertical from any single point along that continued line. The box formed by these lines will be the correct scale and can safely be used. See FIG. 3.

FIG. 5.

After some practice, you'll find a size that you are comfortable drawing. Many cartoonists draw

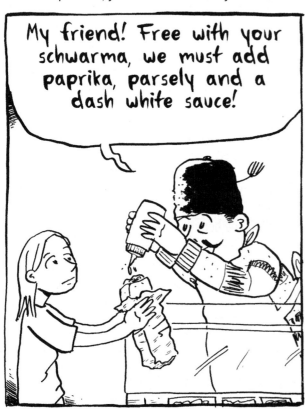

FIG. 6. Original art size for the strip on the next page.

well larger than the size mentioned above, but some do not. I myself began *Hutch Owen* much smaller (see FIG. 4), drawing at roughly 3.25 inches tall, but then expanded when I realized I didn't have the room to get my expressions and environments right. I changed to a size more like 4 inches tall (FIG. 5).

When Margo and I drew *Ali's House*, we drew our original art a tiny bit bigger still (see FIG. 6. When you find a size you're comfortable with, stick to that size. Make yourself a template that you can trace and use each time. Continue to draw this consistent size so you don't have to worry about any of these details again.

Why We Draw Larger

Cartoonist tend to draw larger than print size for many reasons.

First, a larger area allows us more control over our tools. Drawing the tiny size of most print comics would be too difficult for most cartoonists and would prove unrewarding

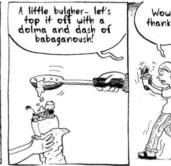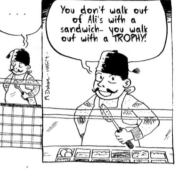

FIG 7.

in the end. Most artists like to engage the muscles in their arms a bit when they draw, and need their original size to be large enough to accommodate that.

In addition, the reduction of the artwork tends to tighten and unify our drawings, pulling all our lines together and making the whole thing seem more readable. (See FIG. 7.) However, we must also be careful to not draw things that will reduce into tiny little blobs. This is especially true of lettering, and will be covered more completely in the chapter on lettering, coloring and inking.

Breaking Borders

It's important to keep in mind that this box we draw in is our maximum live area and can not be broken. If, for the purpose of story or a joke, we feel the need to break that border, we have to give the illusion of breaking the border, by pulling our panel borders inward so that the extended bits of the drawing are still within our live area (see FIG. 8).

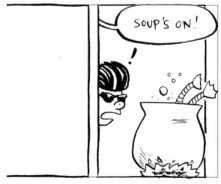

FIG. 8 shows the live area in red (or light grey)

If you want to break the border, you can NOT do this, breaking the live area.

But you CAN move your border further inside the live area and break THAT border. You just can't leave the live area.

Sunday Strips

The traditional Sunday strip is a more complicated matter. The standard has evolved over time into its current form, below (FIG. 9.): a wide, two-part strip whose left-most part is a disposable title panel. Newspapers which choose not to run this title panel will discard it, only printing the remaining right column, and print an un-fancy version of the title at the top of the strip instead.

Traditionally, these strips run around 9 inches wide or a full-sized 12 inches wide. At whichever size the newspaper chooses to print it, the Sunday ratio nonetheless, like the daily ratio, must stay consistent. The ratio of the two boxes are 1 unit wide by 1.25 units tall for the title and 1 unit tall by 2.1 units wide for the main content. These run next to each other with a small space, or gutter, between them. Box 1 is always a title panel and what you do with box 2 is up to you and your editor.

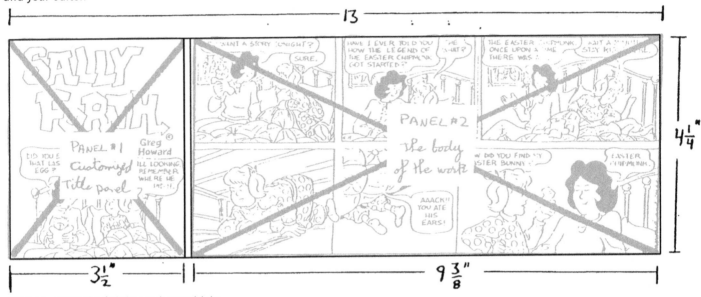

FIG. 9. A Sunday template featuring a customary print size.

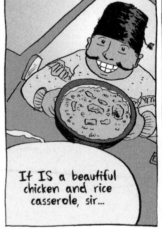
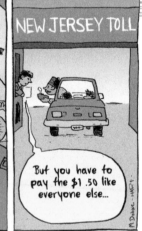

This title panel will be discarded by some newspapers.

This is the core Sunday strip. It can be one tier, like above, or more, like in the next example.

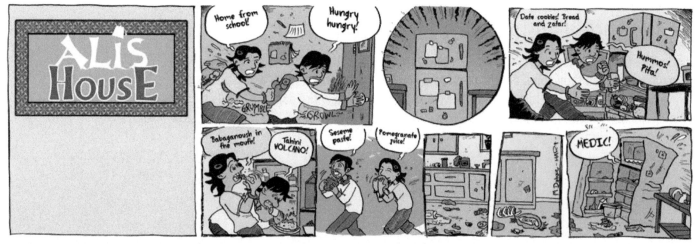

Title area to be discarded. Example of a multi-tier Sunday strip. The dimensions are identical to the previous 3-panel Sunday strip.

Single Panels

The size and ratio of single panel strips like *Bizarro* or *Dennis the Menace* is slightly inconsistent, but in general, the ratio is 1 x 1.25. See FIG 10. These single panel spaces are usually a single newspaper column wide and newspapers will run them in a thin column to the right or left of its other strips.

Sometimes syndicates will sell a multi-panel strip that fits into the single panel space. *Oh Brother!* by Jay Stephens and Bob Weber, Jr. is a recent example of this.

All the same rules of scaling and live area apply to single panels as well.

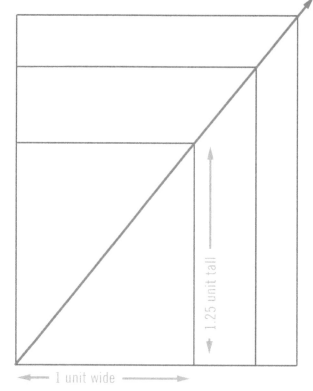

FIG 10.The ratio of this box is 1 unit tall by 3.2 units long.

Sidenote: Comic Strip Size Through the Century

Comic strips were not always this small size. Sadly, they've gotten increasingly smaller and more constricted throughout out the decades. In fact, in their earliest days, a single Sunday could be almost two feet tall, and dailies would span across an entire page. FIG 11. is a clipping of a *Thimble Theater* (Popeye) from a 1938 newspaper, clocking in at 2.5" x 11.75" print size.

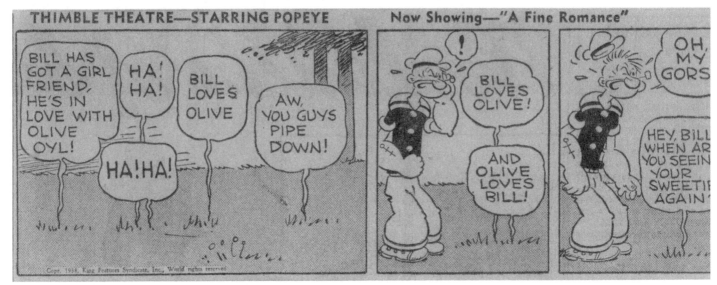

FIG. 11. An actual-size clipping of a 1938 strip.

Strips were already shrinking by the time Charles Schulz came along in 1950 with the big-headed characters of *Peanuts*. His simplified drawings of children with enormous heads allowed for a maximum of emotion and expressiveness while allowing newspaper editors to shrink it while still retaining its legibility.

Peanuts set a new standard for character design in comic strips for this reason, and you see countless cartoon characters for strips now designed at 2 or 2 1/2 heads tall (the size of a character's head being a good system of measurement). I myself normally drew characters roughly 3 1/2 heads tall, but played with shrinking them to 3 and then 2 1/2 heads tall in the middle of my own newspaper days, to mixed results I think. (See FIGs. 12-14.) In the end I preferred the original 3 1/2 heads.

FIG 12. This Hutch Owen is roughly 3 1/2 heads tall.

FIG 13. This Hutch Owen is roughly 3 heads tall.

FIG 14. This Hutch Owen is roughly 2 1/2 heads tall.

Creating A Scenario

A typical question in creating an ongoing comic strip is: Where do I begin?

It seems to me you have two options. You could begin with a character: a fat lazy cat, for instance, or a funny long-haired hippy priest? Those are good starts, sure.

Or you could start with a scenario or a world. An underwater world, for instance, or a comic strip set in a medieval kingdom.

Either of these types of beginnings will lead you to ideas for the other, so for now let's look at *creating a scenario.*

The Scenario

The scenario is the place and overall situation in which your characters and stories are set. *Peanuts'* scenario was a world of children who thought and talked a bit like adults. The scenario for *Pogo* was Okeefenokee Swamp, a place where all sorts of nutty creatures and desperate souls found themselves.

Some strips survive perfectly well with no distinct scenario, or with our ordinary world as their scenarios. Examples of this might be *Zits* or *Cathy.* Some focus on some aspect of our world as their scenario, the most obvious example of this being *Dilbert*, whose scenario is office life, or *Calvin and Hobbes*, whose scenario was the real world of a child's imagination.

If you want your strip to take place in a specific world, era, or scenario, then you must make this scenario something that interests you. If it doesn't interest you, then readers won't find it interesting either. They'll sense your boredom right on the page! But if you begin with something you are passionate about, then you have at least the chance to make them passionate about it as well.

A great example is *Sherman's Lagoon,* a strip set in the ocean by Jim Toomey. Toomey, in a speech at the TED conference in 2010, spoke about his love for ocean animals, and how on a family trip to the Caribbean he fell in love with the ocean for the first time: "I saw a manta ray that looked as big as the plane I was flying in. And I flew over a lagoon that had a shark in it and that was the day my comic strip about a shark was born... From that day on I was an ordinary kid walking around in dry land but my head was down there, underwater." (From a talk at the TED conference in 2010, http://www.ted.com/talks/jim_toomey_learning_from_sherman_the_shark.html)

That is what makes *Sherman's Lagoon* not merely a comic strip, but an engaging series of stories from a cartoonist about something he believes in.

Another great example is Patrick McDonnell's *Mutts*, whose scenario is the world of pets, a simple scenario, but McDonnell's infectious love for animals comes through in every shaky, silly little critter he draws.

When Margo Dabaie and I began *Ali's House,* we began with her background as a second generation immigrant. Her upbringing in northern California might have seemed normal on the

outside, but in fact her family life was steeped in the culture of her father and grandparents, a culture far removed from American culture. For *Ali's House,* we started there, with her childhood culture and the clash of cultures that she wanted to explore.

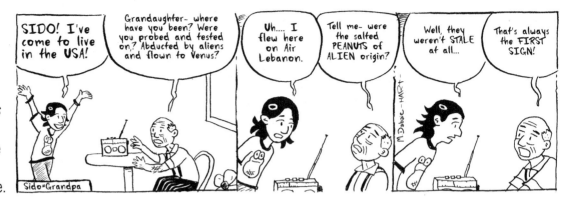

A scenario is a sort of framework, a premise or a larger storyline, even, that the rest of the strip builds on like the foundation of a house.

A simple way to find the right scenario is to ask yourself what you know a lot about. Or ask yourself what you are very interested in. Look to your own hobbies or occupation. If this leads to a great scenario (a strip about plumbing, a bunch of knitters, a series set at the drag races, etc.) then you're in great shape. But keep in mind that a good strip will be about something specific (plumbing, pets, offices) while still welcoming all kinds of people. The key to making a strip appeal to a large number of readers is good characters.

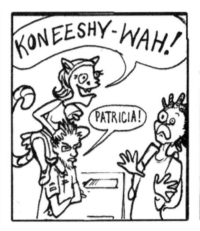
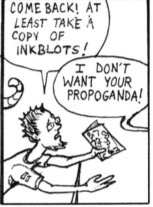

A lot of great strips start as college strips, detailing the scene on the artist's particular campus. This one, from *Ha Ha Constance Planck*, by Hilary Allison, is about the School of Visual Arts student cartooning association.

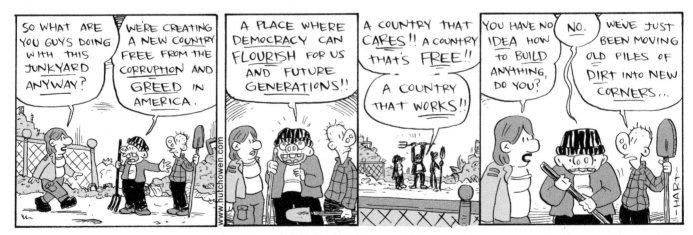

The premise in *Hutch Owen* was that a bunch of nobodies were trying to create their own country.

14

Mail-In Assignment: Creating a Scenario

Create a small list of 1 to 3 possible scenarios.
For each scenario, write it as a simple phrase or sentence in the center of a page.
From there, use the rest of the page to scribble related ideas. Allow other ideas to come, and write down everything. You'll probably need all these ideas someday!

See the example below.

If you like, you may scan and e-mail or photocopy and mail your idea page to SAW and we will try to offer more ideas! There is no critiquing in this stage. We will offer suggestions for other directions to begin thinking about, but these early brainstorming sessions should be free of criticism. (See the bibliography for more about "Foiling the Critic.")

E-mail: thesaw@sequentialartistsworkshop.org
United States Post Office: The SAW, PO Box 13077, Gainesville, FL 32604-1077

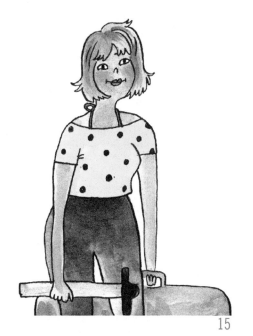

You can do this exercise or any exercise as many times as your SAW account allows.

Creating Characters

Whether you've started with a scenario or not, often the most important thing to do for your strip are good characters. It's with the characters where the readers make the most personal connections to your ideas. You might be a good joke writer, or a good adventure writer, but if the characters aren't someone the readers can identify with and believe in, then they will only be partially invested in your strip. Good characters assure you that your readers keep coming back (unless you're a *really good* joke writer; more about that later) because they're interested in your characters as people.

So how do we create good characters? Like a good scenario, they should come from ideas and traits we are passionate about. The characters have to be meaningful to you for them to be meaningful to others.

Often we begin with a single main character. A grumpy plumber, or a boy scientist, or in the case of *Ali's House*, we started with the girl, Maisa, new to the United States.

The important thing after finding a main character is developing characters that they can then relate to and differ from. Then you are developing a cast of characters, something that will keep your strip running for a long time.

The first rule of in a cast of characters is that the characters need to be different from each other. Try to see the scenario or the themes of your strip from all sides. A grumpy plumber might need a happy sidekick, or an even grumpier plumbing supply salesman (to make our main character seem almost happy in comparison).

Or if you start with a scenario, build characters from that. Is the main theme of your strip the U.S. legal system? Then be sure at least to include a lawyer, a prisoner, a cop, an ex-con, and a judge in your cast. Include a couple serial jury members, maybe a law student, a bailiff, a criminal out to defy the law, etc. Each of those will let you explore your themes from lots of angles.

When we look at our themes from many angles, we give ourselves the opportunity to let ideas come constantly. But also, if we can see both sides of a situation, then we begin to humanize our characters. *Zits* (see it at www.dailyink.com) is such a beloved comic strip partially because both the kid and the parents are *right*. The parents are right that the kid *is* a crazy boundless loon, and the kid is right that the parents are stuffy and uptight weirdos. But the creators see that both sides represent possible sane reactions to the world and as such the whole dynamic

between parents and teen in *Zits* feels like one that goes on within ourselves all the time.

Likewise, the parent/child dynamic in *Calvin and Hobbes*, or even in an extreme dynamic like Charlie Brown and Lucy in *Peanuts*, we can imagine ourselves as either Charlie Brown or Lucy because it was a human dynamic. We feel for Charlie Brown because we all feel a bit like a loser sometimes, but we can imagine ourselves a little bit like Lucy because it IS a dog-eat-dog world out there and we all have our desires to survive and defeat the others, even if we don't talk about it much.

This was often Lucy's motivation and because Schulz portrayed her as human, we were able to understand her and even LIKE her sometimes. It comes from believing in the characters as genuine human beings.

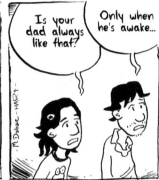

FIG 15.

When Margo and I created *Ali's House*, we had a lot of personal investment in the characters. Margo, having been a child in an immigrant household, felt close to the family of immigrants we created. She was especially connected to the character of Maisa, the little girl fresh to the country (FIG. 15), since Margo herself has often felt like an outsider, even though she had been raised in California on cartoons and video games.

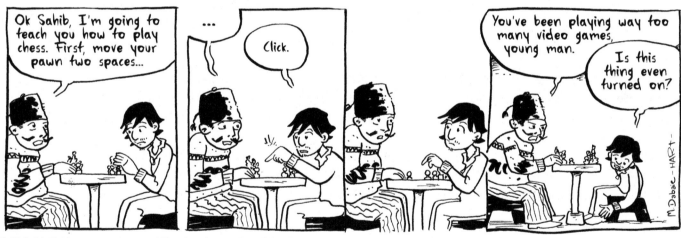

FIG. 16. A strip that in some ways represented Margo's and my creative collaboration.

Likewise, on my end, I invested a lot of my own beliefs about the world in the characters, particularly the main character Ali. Ali was a passionate, boundless creative spirit who felt like his true nature wasn't being allowed to shine. He wasn't being listened to and his music and cooking weren't properly appreciated. It was only after doing it for a few months that I realized that Ali was much like my first solo comic strip character, Hutch Owen, another free spirit who felt under-appreciated and misunderstood.

And since *Ali's House* was a collaboration, Margo and I found that we had created in the generation gap in the household a cartoon symbol of our own creative gap. FIG. 16 is a playful example of Margo and I exploring the difference in our own creative personalities. Me being stoic, bound by tradition, her being more easily distracted and playful.

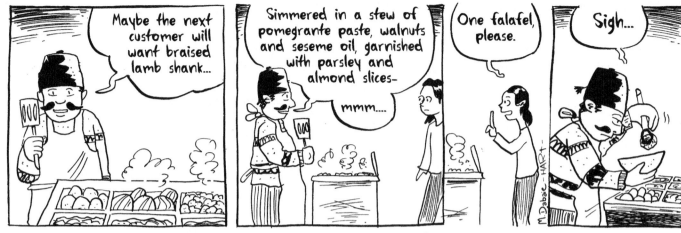

I realized later that Ali, whose best intentions are always being thwarted...

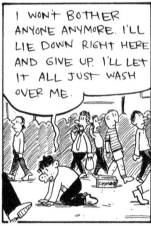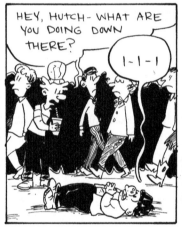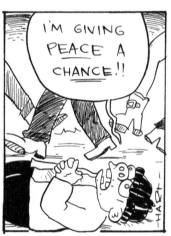

Is essentially the same character as Hutch Owen, who always feels like he is not being appreciated...

To summarize: good characters come from a real understanding about people, and sometimes may resemble the people around you or even yourself very specifically. Look closely at the people around you, and invent characters that let you examine the world in a multitude of ways.

A final word by *Peanuts* creator Charles Schulz: "You must be in constant search for the characters and ideas that will eventually lead you to your best areas of work. The characters that you start out to draw today may not be the same characters you will end up drawing a month or a year from now."

Creating Characters From Your Obsessions

Another way to create a character, particularly if you don't have or know your scenario, is to begin with your own obsessions and hobbies. Create a character with similar obsessions and so long as you remain interested, you will be able to write ideas for your character.

Margo and I as creative people wanted to explore the arts in *Ali's House*, and so created Ali to be creative: both a musician and a cook. In both cases he was exuberantly artistic, even when people couldn't care less.

A good place to start is with a character's job. For instance, a character whose job is a dressmaker or tailor might allow you, the creator, to explore your obsessions regarding fashion.

Likewise, an architect might allow you to access your obsession with the urban environment, and a post office clerk would see all kinds of people, and would allow you to focus on the diversity and strangeness of humanity.

A sports commentator would be a good first character to let you explore your favorite sports. A commentator could interview athletes, change jobs, even try out his or her own talents on the field. All letting you, the writer, grow your interests deeper.

Start with your own interests and obsessions, and let people connect with your stories through your own interest in them.

Quick Character Invention Exercise

Here's a quick fun exercise to create a quick cast of characters.

1. Draw a character who resembles yourself. You don't have to draw yourself as you literally look, but as you feel inside, or imagine yourself to be. This version might be a butterfly, a boxer, or it might be like you really look.
2. Draw a different version of yourself—this version of yourself is you if everything was perfect. Maybe you wouldn't even be human, you'd be a giant robot, or maybe a still tree, or a super hero. Let's call this your "high self."
3. Draw any figure of authority.
4. Draw a monster or some real jerk.
5. Draw a new version of yourself where everything went wrong: maybe you'd be a slug, down and out, or a discontinued robot on the scrap heap. Let's call this your "low self."
6. Give any of these doodles a spouse or a parent.
7. Draw a completely innocent character.

Suddenly, you've got 7 new characters to play around with. Will they all work? Probably not, but a few might stick around if you use them to play with ideas.

Let's play some games with these characters. How might one be related to another? I like to imagine the low self actually in a position of power over the high self. Figuring out a way to do this is an exercise in creating ideas and stories.

Another thing I like to do is have word balloons lying around that I can put over any character's head. Word balloons with things I'm thinking about inside, like "I really need some coffee!" or "We should have an Egyptian revolution right here in the DMV!"

See my FIG. 17, where I've drawn a figure of authority and put "I really need some coffee!" above his head. Suddenly he's less intimidating, more human, and maybe silly, and this might be something I might want to explore.

You can keep going with these characters. You can name them, let them talk or fight with each other, let one try to win something from the other. The characters and obsessions that YOU harbor will create their own sparks. And the more you mix your characters with new ideas, the easier you'll find it to continue.

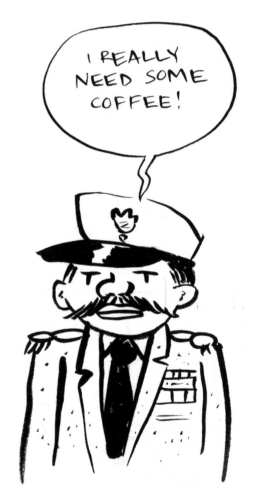

FIG. 17.

Mail-In Assignment: Creating Characters

Create 2-5 characters for your scenario. You can use one of the methods on the previous pages or any other method you choose. Draw or doodle these characters on the exercise sheet.

For each character, try to create an additional opposite or contrasting character. Try to give these contrasting characters contrasting appearances, too.
Write down any ideas about any of these characters that come to your mind.

See the example below.

You may scan and e-mail or photocopy and mail your idea page to SAW and we will try to offer more ideas! There is no critiquing in this stage. We will offer suggestions for other directions to begin thinking about, but these early brainstorming sessions should be free of criticism. (See the bibliography for more about "Avoiding the Critic.")

E-mail: thesaw@sequentialartistsworkshop.org
The SAW, PO Box 13077, Gainesville, FL 32604-1077

You can do this exercise or any exercise as many times as your SAW account allows.

21

Generating Years of Ideas

To keep a comic strip going for years, whether the strip is a soap opera, an adventure story or a comedy series, you'll need ideas and ideas and ideas. Tons of them! How can we can plan for this, and what's the best way to keep them coming?

The main thing in creating these new ideas is that you have to be able to surprise yourself. New ideas will always surprise you, and will lead you to think "what if...?" which will lead you to even more ideas. So it is essential to find a method to keep ourselves surprised.

A few people are good at staring at a blank wall or sheet of paper and then thinking of ideas—but most people aren't like this. Most people need to be stimulated to imagine or see new ideas. For this, I recommend having lots and lots of notes.

You should write a note down when even the slightest, smallest inspiration hits: You see something interesting on the street, like an ice cream truck getting a jump start. You write that down. You see something odd in the newspaper, you write it down. You hear a funny line in your own head or in the street, you write it down. You make a funny sketch, you make sure to keep it.

Then when it is time to write, you take out your notes. Everyone's method of keeping notes will look different, but I think they should allow for some mixing and matching, and thus, some

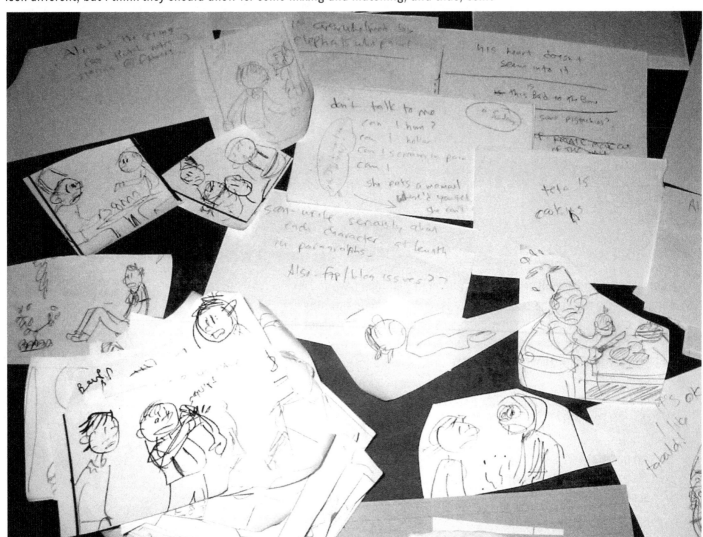

FIG. 18. A photo of some of my own notes and cards that I use to keep me constantly conceiving new ideas.

surprises. My notes for *Ali's House* were a series of index cards, about 5 or 6 boxes of them actually, with different character doodles, word balloons, ideas, emotions or actions on them. (See FIG. 18.) From there, I would combine in random ways different cards and see if any new ideas caused me to laugh and ask "what if...?" If so, I continued with that combination, trying to imagine other moments in the new situation I'd created. I was looking for new details and new *situations*.

A situation is a collision of incidents and details that characters react to. These can be repeated, like Charlie Brown and Lucy and the football in which case we might call it a *routine*. In these cases, such as the one below of Ali trying to eat a gigantic sandwich, the slightest new idea, whether it's a good joke or a slight new wrinkle, will allow you to create new strips.

I personally like to think in increments of one week: 5 or 6 strips worth (I tend to think of Sundays as separate). So when I find a surprising new situation, I imagine new ideas until I have one week's worth that I am happy with. Then I move on to drawing.

If we've done our job up until now, we've created at least a few good, personal characters who can respond to lots of different situations. And now we've learned how to create different situations.

Your situations can be variations on a theme. From the sandwich situation below, I could imagine Ali trying to eat noodles, or a giant steak or any other similar but different food. In these cases, the slight variation will allow me to generate new ideas going far into the future. You have to watch out that you're not being boring, but if you've created rich characters, and you keep looking for new details, you should be ok.

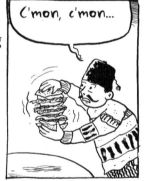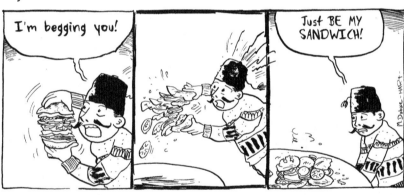

Or your situations can always be brand-new. If you were writing an adventure strip or soap opera, you'd want your characters to always be in a new land, up against new loves and enemies, with new dangers. In these cases, you can be specific on details involving setting, plot, mood, character and props that enable your characters to act, but your main character's morality and abilities will

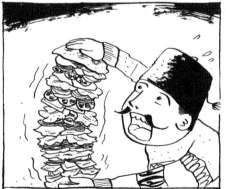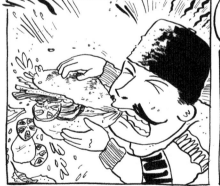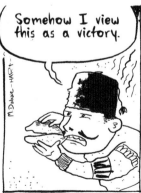

probably remain consistent, and hopefully allow them to escape from the dangers in their way.

Either way, repetition is your friend—learn to love it!

Example: Ali's Headaches

Here's an example from *Ali's House*. At some point, I thought it would be interesting if Ali had a series of crippling headaches (this actually was inspired by my own life. I wasn't having headaches, but I am epileptic, and as such sometimes worry about having seizures. I figured this translated well to worrying about having crippling headaches...)

From this situation I tried always to imagine what the other characters would react. In Ali's mother's case, she knits him a new hat. I pulled a few different cards. A picture of Ali sneezing prompted me to imagine his headache leaving his body. I took out a new sheet of paper (FIG. 19 and 20) and brainstormed other ideas: I let my mind wander to other silly or good ideas. I starred (or x'ed) the ones I liked and developed those into roughs that I could show to Margo and our editor later.

Also, notice in Margo's handwriting the text on FIG. 19, "Your braincase will thank me." This punchline that Margo wrote to my situation turned into one of my favorite thumbnails, FIG 21.

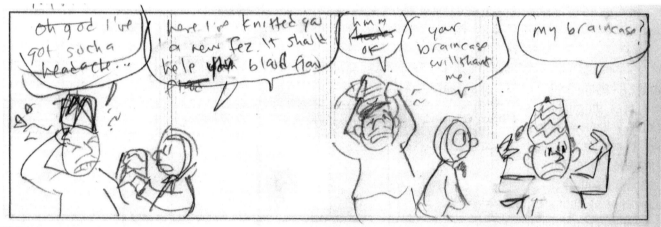

FIG 21.

Voila, the power of collaboration! One way to always be surprised is to work with another person. But since many of us work alone and like to work alone, the essence remains: let yourself be surprised. This means tossing around new ideas and seeing which ones work and which ones don't (keep the ones that don't work in your notes anyway!). Letting yourself make a bit of a mess. Trying things you hadn't thought of or planned already. Letting yourself be surprised.

For further thought, I brought out three doodles from my box of doodles and combined them with my headaches ideas (FIG. 22). All of these can provoke new ideas. On the left, it looks like he

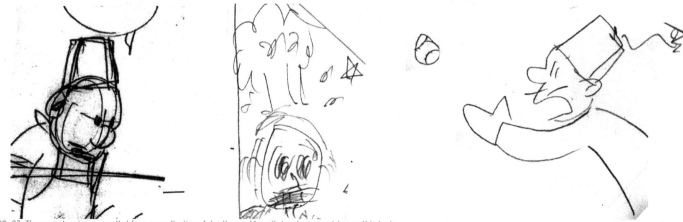

FIG. 22. These random images pulled from my collection of doodles could easily inspire more strips on this topic.

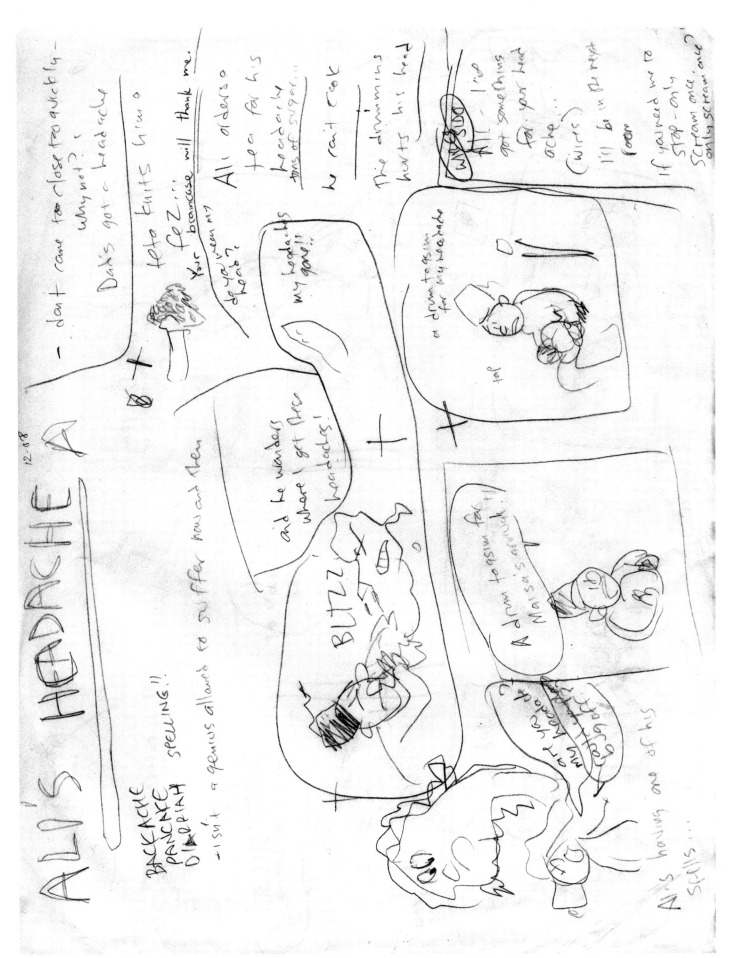

FIG. 19. Side one of a sheet of brainstorming about Ali's headaches.

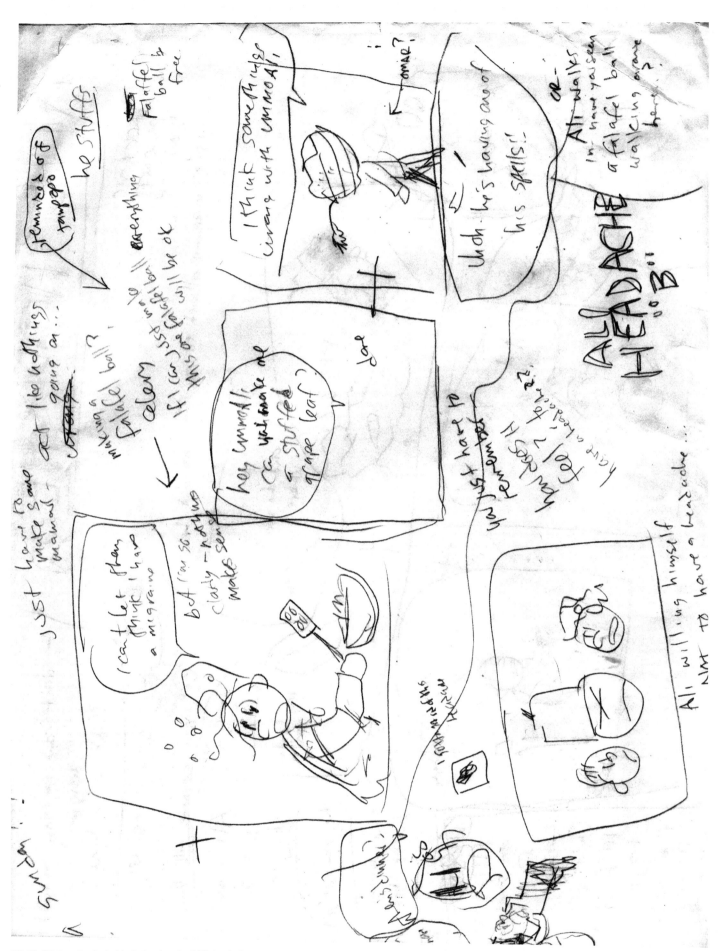

FIG. 20. Side two of a sheet of brainstorming about Ali's headaches.

is confessing to his family. In the center, maybe his head finally explodes in front of customers. On the right, he is trying to keep his cool while playing ball with his son. All good ideas ripe for exploring!

Ideas from Real Life

Of course, another certain way to be surprised is to pay attention to your own life, and draw inspiration from that accordingly. Your life may inspire you to find new characters amongst your friends and relatives, or show you new situations as you move through your own life.

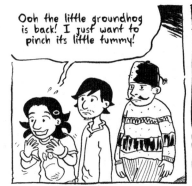 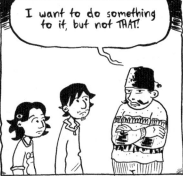 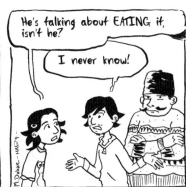

FIG. 23.

In the first example at right from *Ali's House*, my mother was having troubles with a groundhog in her backyard, and so I wrote a series of strips about that (FIG. 23).

In another instance, Margo and I talked about how her grand-parents would put WD-40 on everything, and so we built that into a series of strips (FIG. 24).

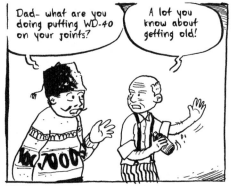 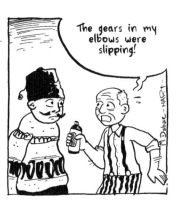

FIG. 24.

And in the example from *Hutch Owen* (FIG. 25), I was certainly surprised when I had a crippling toothache one week, and realized I at least should draw some comic strips about it.

FIG. 25.

All of these strip were inspired by real life, but *transposed* onto our cartoon world and our fictional characters.

Happy Accidents

All of these methods about mixing ideas and surprising oneself are about creating happy accidents for ourselves. We prepare for these moments by creating the circumstances—either by diligent note-taking, memory exercises or spontaneous brainstorming—to be delighted and surprised by our own efforts. Making a mess is actually part of the preparation.

Use your index cards or whatever organizing tools you've decided on. I often shake my cards out of their stale, organized sections and mix them among other ideas and images. I purposefully put notes and scribbles on the wrong sheets, mix the new in with the old, make new notes on tracing paper, or create new computer files on top of copies of old files to allow accidental combinations and layered creations to pop up. It's a mess, but it's the mess of me, and if I examine it closely and intelligently, I can find new ideas and stories hiding there, and begin to craft them into compelling strips and stories.

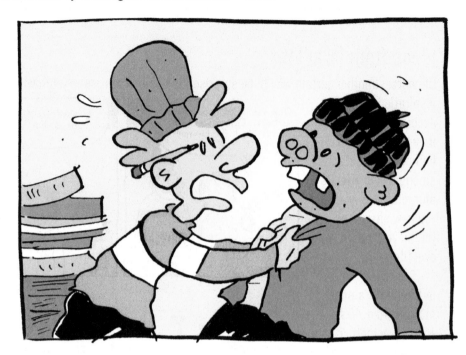

This guy really needs some ideas.

How to Say Everything

The struggle to get your personal life and obsessions into an artistic, story-driven form is, to me, one the most interesting things in the world. I've written an entire book about it, called *How to Say Everything*. The title comes from the idea that you need to "have something to say" before you start working. I don't believe that. I think you can find out what you want to say as you work. And the "something" that you may have to say will feel like "everything" and how do you contain that drive? You don't. You let the drive be the reason for creating, and let the something you have to say come later, as a surprise to yourself. It is an incredibly rewarding, liberating way to work because in this method, you don't have to impress anybody before you start doodling or writing or anything. You just start.

How To Say Everything goes into great depth about creating ideas for comics and stories, and includes more than 50 exercises for coming up with ideas. You'll find information on how to order that book at www.tomhart.net/how-to-say-everything.html, or in the bibliography of this book.

Mail-In Assignment: Generating Ideas

Choose one of the secondary ideas you had from your "create a scenario" assignment.
From there, brainstorm a series of sub-ideas based on that main idea. Let any connection come, and try to fill up
a page of dialogue, situations and other doodles that might apply to this central idea. Use separate sheets for
multiple main ideas. You can use the Ali's Headache pages for a guide, or find your own way to brainstorm.

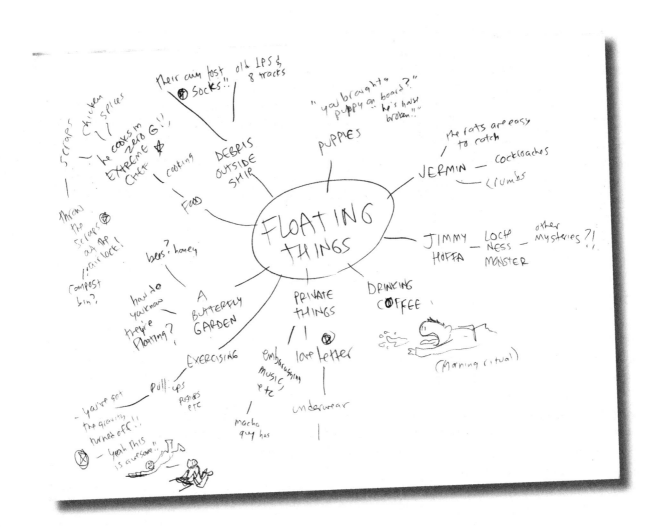

You don't need to send this to SAW; just use it for the next assignment, *Writing Strips.*

If you like, visit the SAW Blog for where you can receive some community comments at this stage. There is no official critiquing in this stage—these early brainstorming sessions should be free of criticism. (Remember to see the bibliography for more about "Foiling the Critic.")

E-mail: thesaw@sequentialartistsworkshop.org
United States Post Office: The SAW, PO Box 13077, Gainesville, FL 32604-1077

You can do this exercise or any exercise as many times as your SAW account allows.

Writing Jokes and Cliffhangers

Coming up with ideas and characters doesn't spare us the details of learning how to craft a joke or a story. Fitting all this stuff into our small space requires some agility and know-how.

Jokes

Telling good jokes and being funny are not necessarily the same thing. A really good joke strip can lure people back time and time again. Gary Larson's gag panel, *The Far Side,* was one of the most loved strips of the last 50 years, his sense of humor so unique at that time that people kept coming back for more.

A good simple joke can be seen in this *Tina's Groove*, by Rina Piccolo (FIG 26). The surprise is to learn that this "everything bagel" has a lot more every-thing that we initially imagine. The joke doesn't rely on the characters to make it work, nor does it really deepen our

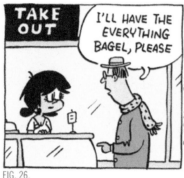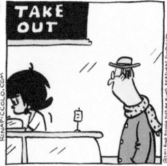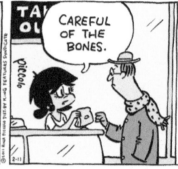

FIG. 26.

understanding of the characters. That's quite alright. Piccolo is a good joke writer.

Inventing good jokes is quite hard, in fact, but you can still use your own sense of humor to make people laugh, even if jokes are not your forte. What you'll have to do is learn to structure your humor and give your characters space to be funny.

A good basic rule to humor in comic strips is to get your characters on different metaphorical pages by the last panel. In other words, they may start out in agreement, or at least in mild disagreement, but by the end, they are holding wildly different ideas about the situation at hand. In other words, they're not ON THE SAME PAGE... The *Ha Ha Constance Planck* strip below (FIG. 27) is a great example. What seems like a casual meet-and-greet becomes a scene to run away from as the dark-haired character realizes he's in a much stranger world than he thought.

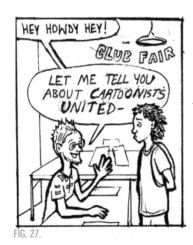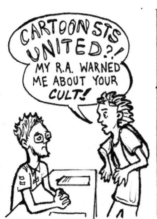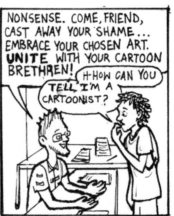

FIG. 27.

Another example from *Ali's House* shows two characters at the end on different pages (FIG. 28, the customer deciding possibly to leave Ali's stand) and allows the character of Ali to grow in the reader's mind (we see just how exuberant and silly he is) while still providing us with a good

little chuckle.

In a playful reversal of this "not on the same page" structure, the humor here in FIG. 29 is that the characters are on exactly the same page ("That's my boy!") but it's such an absurd thing to be in agreement over that the humor comes when the reader's expectations are tripped.

Notice in a lot of these examples, there is a rhythm in the last panel where two characters each speak their final lines almost as if they're both about to give up on trying to agree and split apart. Some writ-

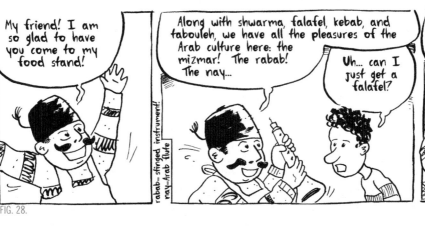

FIG. 28.

 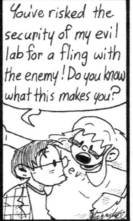 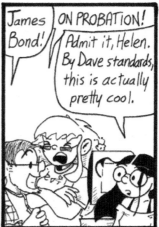

FIG. 29.

ers call this a "soft-punch," where the joke comes from the combination of those two pieces of dialogue, rather than one piece of well-timed funnyness. Contrast these with the examples from *Tina's Groove*, where you'll see only one character in the last panel issuing the punchline. Common wisdom says that this double-dialogue "soft-punch" is easier to write than a single great gag that has to pass or fail on its own merit. I tend to agree. What you're shooting for is not a joke, but a humorous surprise.

Other tricks for a humorous surprise are by revealing information in the last panel that clarify the previous panels. The *Ali's House* Sunday strip seen earlier where Ali is revealed to be offering a stew to the highway toll-collector, or the *Hutch Owen* toothache strip from the previous chapter are good examples of this.

The humorous surprise can come from your wit, your visual ideas, or your characters and dialogue, but either way leaving the reader surprised and amused is the goal.

 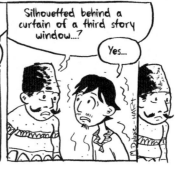 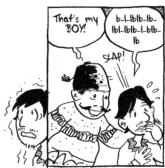 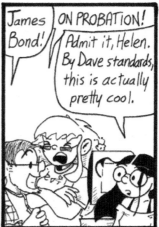

In the example from Shaenon Garrity's *Narbonic*, three short punchlines add up to one laugh at the end of the strip.

Storylines and Cliffhangers

The difference between a situation which you explore (Ali's Headache, Lucy and Charlie Brown's football kicking, etc.) and a storyline is that in a storyline, the situation changes, and readers keep reading to see how. In a storyline, the main thing a strip needs to do is to keep people reading. You do this with great characters, surprising situations and suspense-filled cliffhangers.

In a typical comic strip storyline or serial, there is a main character whom we follow through their adventures in either love or danger. The character's personality rarely changes, but what changes is the situations they find themselves in. When their circumstances change, we watch them overpower or fall to their adversaries.

Some of the classic serial comic strips, like *Buz Sawyer, Popeye, Little Orphan Annie, L'il Abner, Dick Tracy,* and *Terry and the Pirates,* all kept the readers involved by surprising them and keeping them worried for their characters day after day after day for decades.

In newspaper strips, it's important to remember sometimes readers are jumping into your story midway. You need to allow enough of a complete idea, or enough of a tantalizing detail of an idea, to keep people coming back tomorrow. In many newspaper serials throughout history, you'll see in today's first panel a gentle recap of yesterday's final panel.

The important thing is to keep the laughs coming, or the suspense heightened in the last panel. If readers want to know what happens tomorrow, then you've done your job. Tomorrow's strip can be the result of today's cliffhanger, and hopefully tomorrow will offer some suspense too.

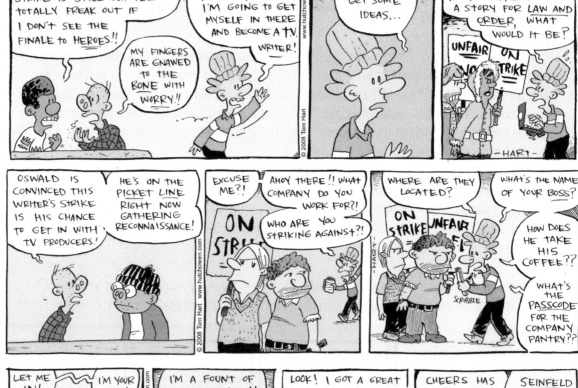

In this series of strips, you can see the first panel of the second strip recapping the last panel of the first. However, there's a logical leap between the end of the second strip and the beginning of the third. Both are permissible methods of unfolding a story, so long as each strip remains reasonably self-contained.

Note that surprise is at the core of both humor writing and serial story writing. Offering readers a gentle surprise is the whole reason strips exist.

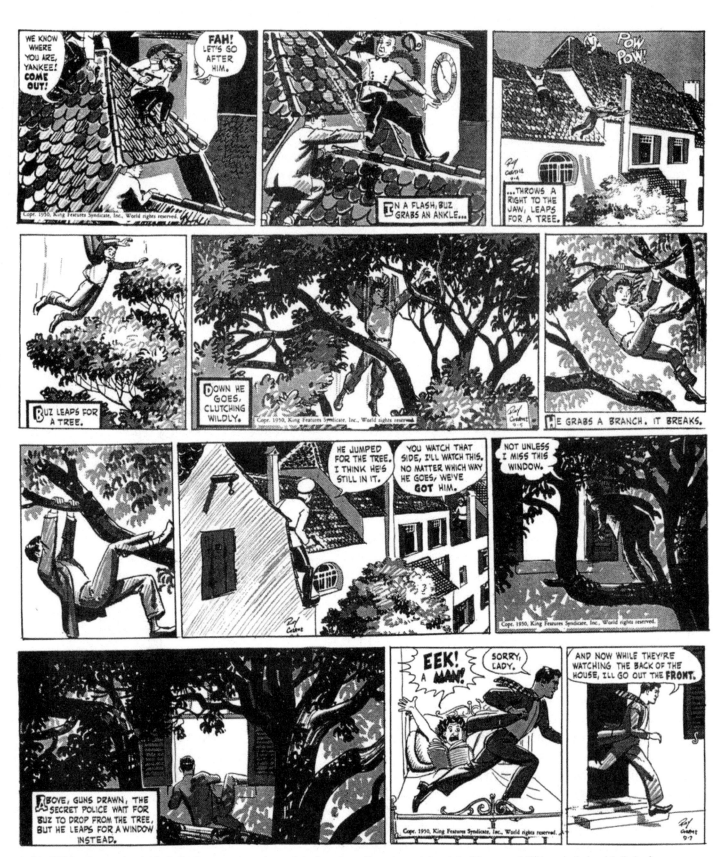

In this 1950 *Buz Sawyer* series of strips by Roy Crane, you can see how each day Crane leaves the reader wondering what will happen next. Will he make the leap into the tree? Will he make the leap into the window? What will he encounter when he runs out the front door?

Mail-In Assignment: Writing Strips

Whether you're creating a story strip or a humor strip (or both), write 3-5 of these strips for your scenario. You can either script these, using words, or draw a thumbnail sketch for each (see example below). Make sure they are readable enough for us to see. Write dialogue and text on the side or in a margin if it will be unreadable in your thumbnails.

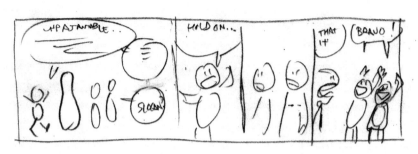

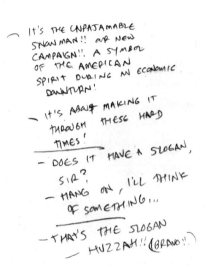

Example of a thumbnail sketch: showing the main parts of the strip. You can fit the full text in this sketch, or include it on the side like here.

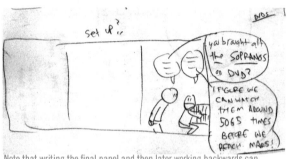

Note that writing the final panel and then later working backwards can sometimes work well.

Scan and e-mail or photocopy and mail your this assignment to SAW Headquarters at:
E-mail: thesaw@sequentialartistsworkshop.org
United States Post Office: The SAW, PO Box 13077, Gainesville, FL 32604-1077

We will return your work with critique, notes and suggestions for further development.

You can do this exercise or any exercise as many times as your SAW account allows.

Drawing for Strips

Drawing for comic strips needs to aim for two goals: clarity and appeal.

By "clarity," we mean the basics: can we tell the characters apart? Can we easily read what's going on? Is everything fitting? These sound like simple questions but in fact, it's where most starting artists get it wrong. We have to remember that your average reader will spend a few seconds on your comic strip at most, and if it isn't clear, they won't even try reading it. The most important issue is clarity.

And by "appeal," we mean: Do readers like looking at your characters? Are your style and your drawings pleasing and do they invite readers back?

These fundamentals of clarity and appeal relate in all factors of your drawing, such as these:

Character design: *Can a reader "read" the expressions on your character? Can we tell what it is and what it is doing? Do we like looking at the character?*
Fitting elements in the panel: *Are they big enough to communicate the idea, and no smaller than they need to be? Will they be readable at their final size, whether that's in a newspaper or online? Are they too cluttered and is the whole thing unreadable?*
Shots: *Am I choosing the right shot (meaning camera distance, etc) to get the point across?*
Place: *If it's important for the strip for us to know where events are happening, can we?*
Lettering: *Can we read it? Does the style fit with the rest of the drawing? (Lettering gets its own section a little later.)*
Style: *If my drawings are heavily stylized, are they still legible and pleasing?*

Character Design

The main issue with our characters is: Can we tell what our character is and what it is saying and doing? When it is showing emotion, can we tell what emotion it is? This pickle in FIG. 30 is pretty good and clear, but the potato next to him might be a little confusing, since the eyes he sees with are so similar to the potato eyes all around his body.

The alternative design to his right might be better. The potato again: now his eyes and face are fully readable but his angry look brings us to the question of *appeal*: Is our new design appealing as a character? It's an important issue, and in the end up to us and our readers.

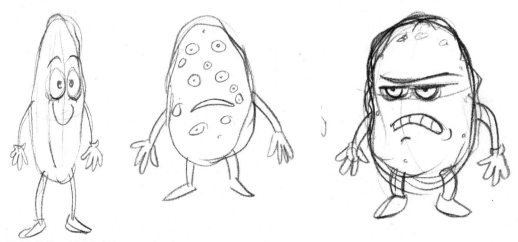

FIG. 30. Pickle and Potato designs

Fitting Everything in the Panel

Fitting what you need to fit into the panel is like a little puzzle. You'll see a lot of sketches and loose pencil drawings in this section, because those are the best stages to solve these problems.

Space in comic strips is valuable, and we do our best to include only what is necessary. First what we need to consider is: what is the bare minimum we need to show to get our point across? For instance, if we don't need to see the character's feet, or the character's pants, or the kitchen where he's sitting, then we shouldn't show it so we can have more room for the character's appeal and "acting" to come across. Likewise, if it's essential to show that they are in a kitchen and it is Thanksgiving, we need to show the fridge, and probably a turkey, etc. In the *Hutch* example below (FIG. 31), it was important to show that the action was taking place in an office,

so at least one panel was used to establish this scene.

Additionally, we probably have dialogue, and we have to make room for our dialogue bubbles, or *word balloons* to show. It is essential to the readability of our strip that our lettering and lettering balloons fit into the space in a way that is

FIG. 31.

uncluttered and easy to read. Lettering, in fact, is so important, it gets its own part of a chapter later.

FIG. 32 shows some common mistakes fitting everything in the panel: not having enough room for dialogue and word balloons, leaving too much space empty, and cutting off character's faces.

In the puzzle of fitting everything in, it's important to start with the general shapes of our char-

acters and balloons, to make sure we're getting it right. That first stage of fitting everything in is done in a smaller sketch called a thumbnail sketch (FIG. 33).

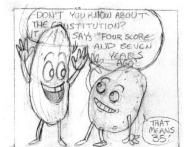

FIG. 32. Some common mistakes in our panel composition: Not enough room, too much room, cutting off important visual parts of the scene with dialogue.

Then add details, starting with the lettering next (see FIGs. 34-35). Then, we clean up and finish (see the chapter on inking, lettering and coloring, showing all of this in detail).

Once we've fit everything in, there's still the matter of appeal. Are the characters standing, sitting, emoting our relating to each other in a way that reader's will respond to? Again, that's up to you, your readers and your

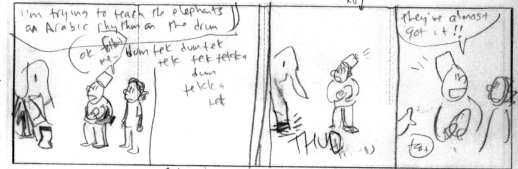

FIG. 33.

editor, but some of the following issues should be carefully considered.

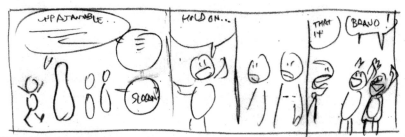

FIG. 34. The thumbnail sketch helps you fit the main parts into the strip.

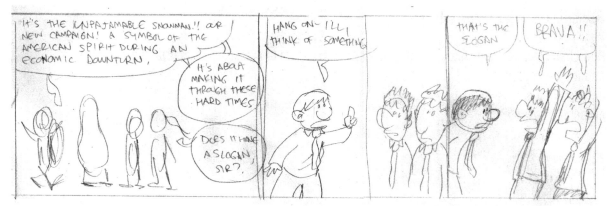

FIG. 35. A full-sized rough draft, still trying to fit all the elements together, now with the dialogue and characters more specific.

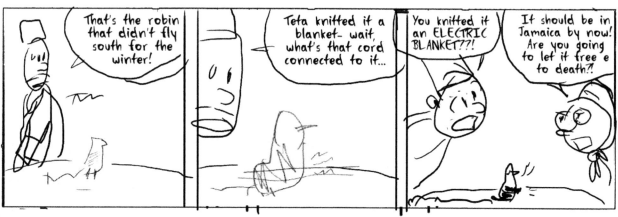

This sketch was drawn on a computer with a digital pen and tablet.

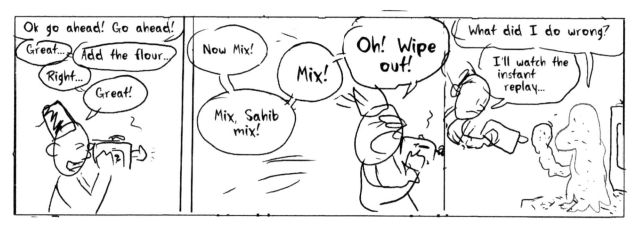

The various placement of the word balloons helps extend this sequence in which we imagine what it that is happening off panel...

How Characters Relate in the Panel

Real people move. They talk with their hands and their eyes, they stand with their weight on one leg, then the other, they constantly shift according to who's around and what's on their minds. Likewise, our cartoon characters need to act like people do—relating like people do, moving when they talk, sharing space, and generally relating to each other. When characters don't relate to each other visually, it can look like a bunch of rocks standing around, like an eons-still Stonehenge waiting for the sun to appear in the right position. But in the hands of someone who puts their characters in the same space, suddenly we're seeing cartoon humans in action, actively, visibly in the same story. Search for some examples from Milt Gross or E.C. Segar for masterful examples of this.

How characters relate in space is one of the key components of classic character animation, and it involves understanding of facial expressions, emotion, body language, and other forms of "acting" that you as the cartoonist need to be in control of.

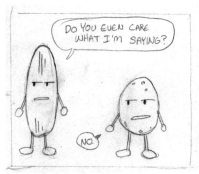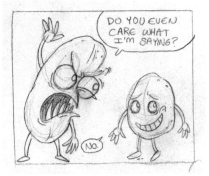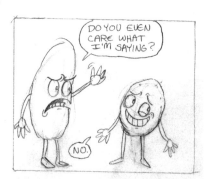

Some common mistakes in how characters relate: Not engaged with each other or over-invested (or over-acted). Though the first two examples might find their audience, the third example seems most realistic.

Many books have been written that cover this material. I recommend Preston Blair's *Cartoon Animation* or perusing the blog of *Ren and Stimpy* creator John Kricfalusi for lots more on this crucial topic.

Positioning your characters relative to the "camera" or picture plane. Too much in profile tends to be distancing. Directly at the camera is off-putting, unless the character is actually supposed to be speaking to the reader. A 3/4 view, whether in close-up or medium shot is generally what communicates most naturally.

Additionally, the role of some real figure drawing practice can't be underemphasized. Every cartoonist worth his or her salt has had some degree of life drawing—or drawing from a live model—to help them understand and gain practice in how a human body moves in space. There is likely a life drawing class in your town or city, but even if not, then getting pose books or finding poses online and then practicing drawing them will help your ability to cartoon that much more.

In the end we have to realize that whether about fish, or witches, or pickles and potatoes, our stories are people stories, and our visual and psychological understanding of how people tick will help immensely.

Composition

How everything fits into a panel or frame is called the art of composition, and involves much much more than merely making everything clear. How you engage a reader's eye, to what order they see things, to whose point of view they are looking from, to how objects are frames, to where characters are looking—all these things affect what a reader believes when they look at your single panel or drawing. It's very complex stuff, and again, there are entire books written on it (see the bibliography for books on graphic design and composition), but some basic rules ideas to think about are:

- A good composition tends to lead an eye around the composition through the focal area.
- A good composition will frame important areas of focus.
- Contrast in directions of lines and action tends to make a composition pleasing and dynamic.
- Contrasting black and white often draws the eye's focus.
- Word balloons and other abstract parts of the panel are still active parts of your composition and must be given equal importance.

Shapes and character gestures all lead the eye in specific ways here.

- Readers tend to start in the upper left corner when looking at a strip, then move their way to the right. This is why we tend to put the text at the top.
- A good strip will use its elements of composition to lead reads visually from one panel to the next.

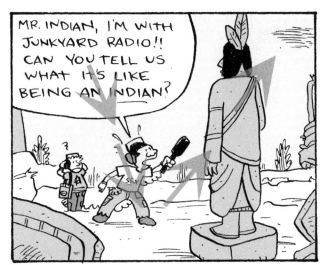

The word balloon tail, sweat drops, and boy's leg all form one half a "V" shape that leads the eye to the upper right of the panel—through the microphone, Indian's robe, and finally the clouds in the sky.

The main action here is small high-contrast areas (white grey and black) all framed by white space.

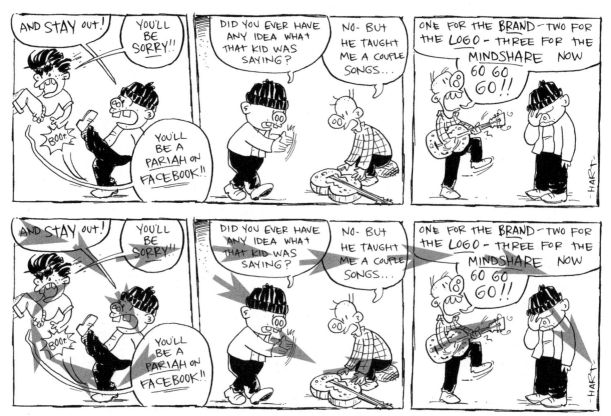

The arrows show where the reader's eye is likely to go in this complexly composed strip.

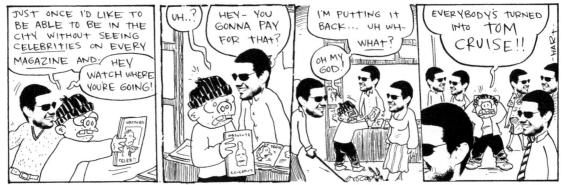

The many duplicated high-contrast faces lead the reader through the strip here.

Choice of Shots

Cartoonists and strip artists tend to use movie terminology when it comes to planning their drawings. We speak about shots and camera placement, long-shots, medium-shots, and close-ups as we might if we were discussing a film. Of course, there's no real "camera," only a *picture plane* where the artist chooses to place his viewer, but the film terminology is simpler and of just as much use.

Medium-shot

Comic strips tend to rely heavily on medium-shots. This is due to it often being a verbal medium, where conversation moves the action and so a head and shoulders shot of a couple of characters is all you need. Many strips rarely move beyond this. See FIG. 36.

But you will need other shots such as long-shots and close-ups, and will probably need the occasional silhouette and establishing shot. So let's take a quick look at when you might use each.

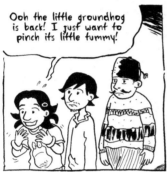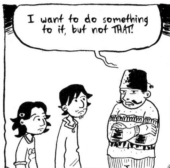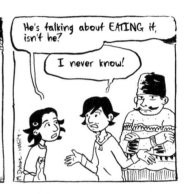

FIG. 36. A strip composed entirely of medium-shots.

Close-up

Close-ups are good for when a reader needs more information like in FIG. 37, below (the reader needs to see the cords coming from the bird's blanket), to draw attention to something in the panel, or to show emotion on a character's face.

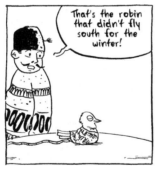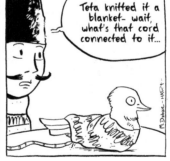

FIG. 37.

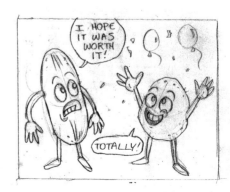

Some examples of using close-up in conjunction with other shots. The close-ups in panels 1 and 2 also help the celebration seem more surprising.

Long-shot

Long-shots are needed to establish place or context. In this episode (FIG. 38) from Patty and

Terry Laban's *Edge City*, we need to see and feel the snowstorm in order to feel the characters' frustration. The artist needs to make a convincing case that the storm is bad and causing problems. Of course, a less interesting cartoonist than Laban might have had the whole strip in medium-shots and hoped that the dialogue in

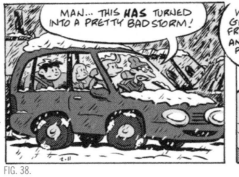

FIG. 38.

panel 1 got the point across, but instead he and Patty chose to get the reader involved by showing just how bad that snowstorm is...

In a similar example from *Ali* (FIG. 39), we had to show that this snowstorm was one that an old

lady clearly couldn't go walking in, but she could bundle herself up and be taken somewhere. So we tried to show that in our first panel. (It's actually a long-shot on the boys and a medium-shot on the grandmother in this instance.)

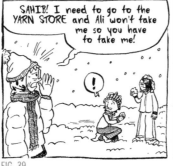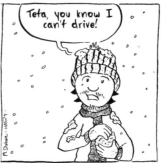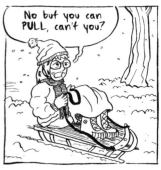

FIG. 39.

There are two key variations of the long-shot: the establishing shot, and the silhouette.

The establishing-shot is a shot of place only, to establish where the characters and action are. This often utilizes word balloons as well, but the key point is that its main purpose is to show where things are happening. FIG. 31, earlier, shows an example of this while FIG. 40 shows a variation: putting the establishing shot later in the scene, partially to break up the rhythm of the strip, and partially because with so many word balloons a character wouldn't really have had room, but also because delaying the visual of what was happening made it funnier.

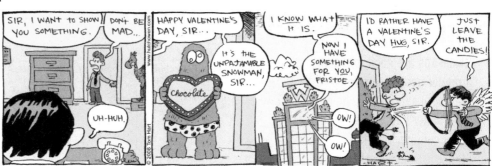

FIG. 40. The establishing shot here in panel 3 helps hide the surprise of the bow and arrows until panel 4.

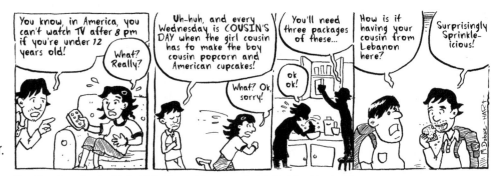

The action of messing about in the kitchen in panel 3 was important, but not the characters' faces.

Lastly, cartoonists will often use silhouettes when a long-shot would work well but there either isn't a lot of room, or the artist feels that the reader can use a visual break in the strip. Often the silhouette is good when you want to show action in a character's gesture, but his or her face isn't necessary to see.

Place

A sense of place is important in much cartoon drawing, but it's something that tends to disappear as nonessential in some comic strips. Sadly, there just isn't enough space to fix complex environments or backgrounds most of the time. However, there are times when you need to establish a sense of place, and again the basic rule is clarity: show us what we need to see, and don't make anything overly confusing. If we don't need it, you probably shouldn't show it.

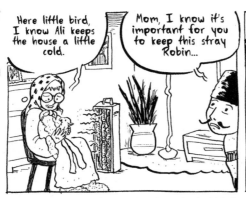

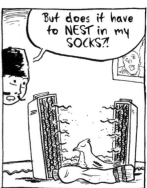

In the example from *Ali's House* (FIG. 41), we felt it was important to see the comfortable house in which the grandmother was sitting, because she wanted that same comfort for her pet bird. So we showed a lot of it in panel 1, shrinking our strip to only 3 panels and keeping other panel complexity to a minimum. Panel 2 features no background, and panel 3 features very little in the way of anything but the comfortable bird.

FIG. 41. It was important for us to show the comfort in which the grandmother expected her bird to live.

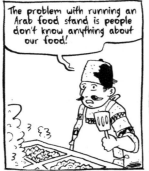
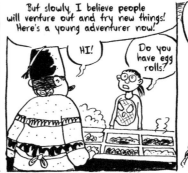

In this *Ali's House* (FIG. 42), it was important to show Ali at his tray of food at the food court, but we didn't need to see the food court itself, or much of anything else but the food tray. So that's all we showed.

FIG. 42. Here we just needed to establish he was in front of some hot trays of food.

Lettering

Lettering gets its own section later, but is relevant here because it is a natural part of composition and because it relates to the issues of clarity and appeal. It is of the utmost importance that your lettering be clear. This means:

- A legible typeface
- Good spacing between letters
- Good spacing between lines
- Good spacing around words inside balloon
- Balloons that are clean and simple, part of the composition and that work in the larger drawing, etc.
- The right typeface for your style.

For now, as you're working in pencil drafts, the important thing is to make the lettering and the balloons each clear. See the lettering section in the next chapter for all of this detail.

Take Home Assignment: Drawing Your Strips

Create 3-5 strips in pencil only at this stage. Work to fit everything in there: lettering, balloons, characters, gestures, expressions, props and backgrounds where necessary. Try to choose the appropriate shots for each panel. Begin with thumbnail sketches if you like, and send those along with your penciled strips to:
E-mail: thesaw@sequentialartistsworkshop.org
The SAW, PO Box 13077, Gainesville, FL 32604-1077

You can do this exercise or any exercise as many times as your SAW account allows.

Many artists start wth a thumbnail sketch first, so named because it is small, like a thumbnail. Then after working on loose pencils at full-size, trace them on a lightbox or some their method to complete their final pencils (see below).

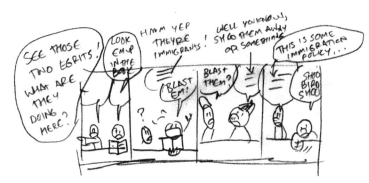

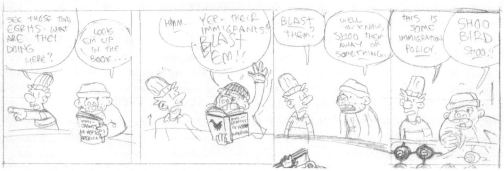

This bottom strip was traced and refined on a lightbox from the full size sketch above it.

Inking, Lettering, Coloring
Inking

Why are comics usually drawn with lines in ink? Three primary reasons:

1. **Tradition**. Comic strips come out of printing technology, which in its early days could ONLY print line. Etching, woodblock were printmaking forms that translated well to early periodical printing technology. The printmaking technologies are fun, and working in line with brush and pen in ink is a carrying through of that tradition that cartoonists tend to embrace gladly. (FIG 43) Learning from master cartoonists and illustrators means learning THEIR linework and copying it, and incorporating it into our artwork, thus continuing the tradition begun in the days of etchings.

FIG. 43. William Hogarth's Gin Lane, an engraving from 1751 satirically depicting the horrors of gin addiction.

2. **Ink is easy to print.** Ink lines show up for the cameras that shoot the artwork for newspapers, and are easy for printing presses to print. They show up boldly even on coarse newsprint, which doesn't take subtleties in artwork very well. However, we're now entering a new phase where these printing technologies are less important. Newspapers can print full color (though the papers are still coarse and difficult to print subtly onto) and with distribution and presentation on the web, virtually any media can translate into a comic strip.

3. **It's easy to read.** Cartoon characters need to be read quickly, as part of a whole idea incorporating text, story, and idea, as well as character. Drawing simply with line makes the character easy to see and therefore easy to read.

Of these, this last one is the most relevant still. Our characters can't be full-fledged drawings full of the subtitles of master life-drawings or a painting by Van Gogh. Ideally our characters are easy to scan so our audience can read our strips: text, character, background and all, in one simple motion.

Drawing in Line

Most professional cartoonists draw with a flexible pen or brush. This allows for one of the most important aspects of drawing in line: *line variation.* Drawing a line that changes from thin to thick or thick to thin is at the very heart of for engaging the eye and drawing characters with a believable *form.*

Take a look at the most popular comic strips now and in the last 100 years and you will see drawings with line variation. Some have a lot, some have a little, but almost all understand the importance of varying the linework.

The simplest form of line variation is to use thick lines for objects in the front and thinner lines for objects in the back. This mimics the way the eye works in the real world and helps create an illusion of depth, seen in FIG. 44.

FIG 44. The line variation on the main characters plus the lack of detail or strong line on the background behind the main characters help make this drawing more instantly readable.

But more often than not, there is line variation on everything in the strip. It engages the eye, helps generate a sense of form, and makes the whole strip believable.

Tools

The tools that cartoonists usually draw with are brushes or flexible pen nibs that dip into india ink.

Pens

Pen nibs are tiny steel pen points that fit into plastic or wooden holders, and are designed for dipping into ink and creating flexible lines. There are hundreds of pen nibs out there, all offering different sized lines and differing amounts of stiffness or flexibility. Many cartoonists use a couple in any single strip. You can see in FIG 45. how different nibs give different lines. Pen nibs are cheap and easy to clean (wiping them frequently with a paper towel is usually all they need).

There are some refillable pens on the market that offer a little bit of line variation (the Rotring Art Pen is one) but the variation is slight compared to real nibs.

Markers and non-flexible disposable pens are good for lettering, drawing borders, and sometimes doing small hatching or using in backgrounds, but for the most part are not used on characters, who need the more life-giving line variation that real pen nibs and brushes can give them.

Brushes

Standard cartooning brushes are round watercolor brushes, with bristles made of animal hair or a synthetic substitute. These brushes made for painters can run in various sizes, but cartoonists tend to choose between a size 0

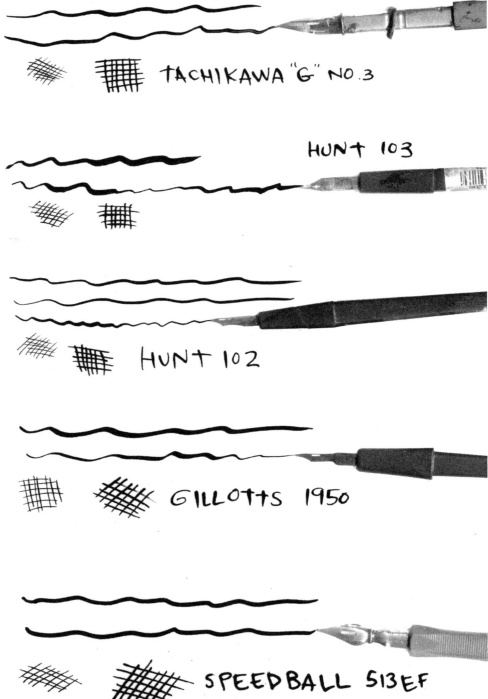

TACHIKAWA "G" NO.3

HUNT 103

HUNT 102

GILLOTTS 1950

SPEEDBALL 513EF

FIG. 45. An assortment of lines and the pen nibs that have created them.

(very small) to size 3 or 4 (a little larger). (See FIG. 46.)

A brush will allow for a lot of line variation, and with practice, will create very fluid lines. Even the largest brushes can create very thin lines when held upright and gently (FIG. 46). Brushes will last between a few weeks to a few years depending on how and how often you use it. After a while, the bristles will fray and it will no longer create a line. Then it can be discarded or saved for filling in large areas of black, etc. Brushes need to be gently cleaned with water and sometimes soap at the end of every drawing day.

There are a number of good brush pens on the market. These are refillable with ink and last a long time. They tend to not have the same flexibility as real brushes, but are good enough and not having to dip them into ink is a bonus some cartoonists love.

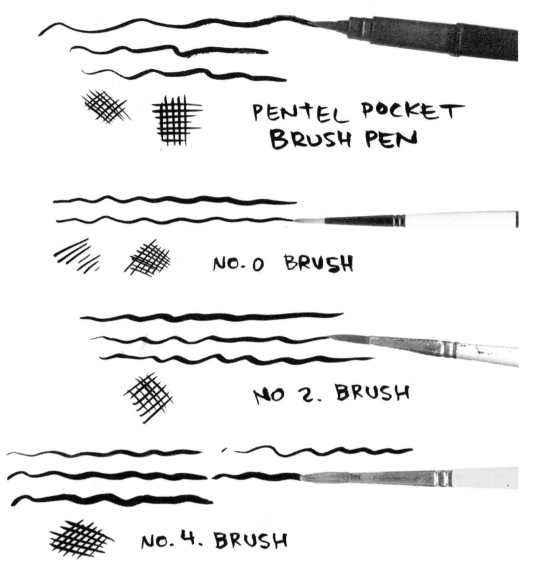

FIG. 46. Brushes and some of the lines they create.

Ink

Get water-proof, black india ink. It has to be waterproof or it will bleed and spread if you ever get a drop of water on it. Dip your entire pens and brushes into the ink, but never their holders. With brushes, only dip the bristles, never the metal ferrule that connects the bristles and the handle.

How To Ink

Remember our drawing goals, of clarity, appeal and style. When inking, clarity and style are the two we need to focus on a bit more than appeal, which gets sorted out in our pencils and character designs.

And like in the previous chapter, most important is always clarity. Clarity in inking is a often a game of contrast in line styles and widths. There are few rules, except that bigger masses (the muscles of legs and arms, the back of our head, our bellies) tend to look right with thicker lines, and smaller details (our knuckles, our eyelids, our fingernails, textures on clothes and objects) tend to need smaller lines. Further, as stated above, objects in front, whether character or lamp or car or tree, tend to look right when rendered thicker than the objects in the back.

An important trick for clarity is CONTRAST. The eye is naturally drawn to contrast, and usually in our comic strips, this means solid black areas on the white of our paper. The use of black areas to guide the eye through the strip (called "spotting blacks") is an important aspect of cartooning and should be understood, though like many variables in art has few rules and is just something you have to wrestle with to a level of comfort with regards to your own art.

Look at FIG. 47a. See how the eye doesn't really know what to pay attention to? Too many shapes competing for our attention. If we fill in some black areas (FIG. 47b) suddenly, our eye has a place to focus. This simple principle is used over and over again in strip cartooning.

FIGs. 47c-47e show some black areas leading the eye to the focal point with different types of sharpness, coolness and urgency. Experimenting with and understanding these concepts is complicated but necessary.

FIGs. 47a-47e.

There are some easy ways to get contrast to work for you in the simplest comic strips. If you don't want to think about it too much, make sure there is a little bit of black on most of your characters, a lot of black on a some, a little black on objects of interest and then some black behind your word balloons if your balloons tend to be at the top. What this will create is a natural series of dynamic focal points (the black on the characters and objects) and a large contrasting block framing your main action. How you render these areas of contrast is up to you. See FIG. 48 from *Ali's House* to see a couple options.

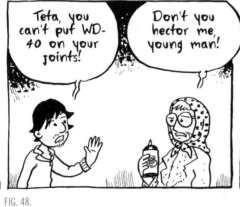 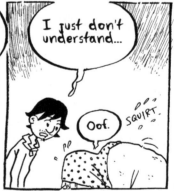 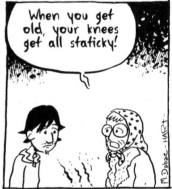

FIG. 48.

Creating an inking style is a game for you and your muse to play. It takes time, and is sometimes more unconscious than conscious. Style tends to creep up on us while we're trying to mimic other artists, master our tools or create some sort of emotional effect. Artists from every art form will say that the natural ways in which our own work differs from a perfect goal in our head tends to become our "style." It happens to us as we are shooting for other things. That said, we can also experiment and try things, and in doing so we may find something that works surprisingly well. FIGs. 49-55 show some experiments in style that may get you thinking as you learn your cartooning craft.

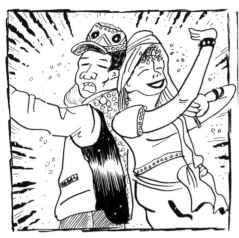

FIG. 49. Explosive, "energy lines" to highlight important moments.

FIG. 50. Stephanie Mannheim used a sponge around the edges of a circle for this effect.

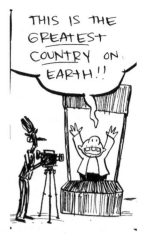

FIG. 51. Loose sketchy side character.

FIG. 52. A form of silhouette: gently shadowing the main characters

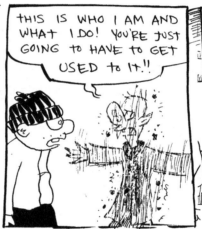

FIG 53. Scratching with a knife over the drawing created this illusion of disappearing

FIG 54. Cutting and pasting other imagery into the panel.

FIG 55. A brush pen mostly out of ink was used here around the edges. White stars were added with a tiny paintbrush last.

Inking on Computer

Some cartoonists will do their inking on a computer, using Adobe Photoshop, Corel Draw, Adobe Illustrator, or some other software. Most will use a digital tablet and pen (Wacom being the most common manufacturer of these) connected to their computer. This allows some cartoonists to bypass the scanning phase, and to keep them from using ink, etc. Some cartoonists will even pencil and brainstorm on the computer, never touching paper anywhere in their process. All of these methods are of course totally fine.

When inking with a computer, you should be aware of your pen sensitivity settings as well as your tool settings with the software you are using. There are too many variables to discuss here, and you'll have to find your own method.

Working on the computer can be liberating for some and frustrating for others. For instance, I find inking with a computer set-up very difficult, and have little of the hand-eye coordination that I ordinarily have when working directly in ink.

I encourage you to find your own methods! There are plenty of tutorials online.

FIGs. 56 through 59 show some glimmers of the possibilities of inking with a computer.

FIG. 56. Inking samples from a Adobe Photoshop brush and a cheap Wacom tablet.

FIG. 57. Inking samples from an Adobe Illustrator brush and a cheap Wacom tablet.

FIG. 58. Inked using a low-end tablet and pen with a Photoshop brush over top of the initial sketch.

FIG. 59. Inked using a low-end tablet and pen with a Illustrator brush over top of the initial sketch. Note the more fluid lines.

Shading Film and Mechanical Tones

Some cartoonists use shading film or its computer equivalent to add a range of values over their artwork. This used to be done with hand-cut transfer paper called *shading film* which had mechanical dots printed onto it (FIG. 60). This shading film came in a variety of brands, most commonly Zip-a-Tone, Letratone, and Chartpak.

Much more commonly now, if this is done at all, it is created on a computer. After adding one or more grey values to artwork, you can convert those values to dots through any number of computer filters. Here, in FIGs. 61 and 62, I've used the Photoshop "Color Halftone" filter to create the dots.

FIG. 60. A sheet shading film scraps after the bulk of it has been used up. Pieces are cut then placed on artwork to create grey tones.

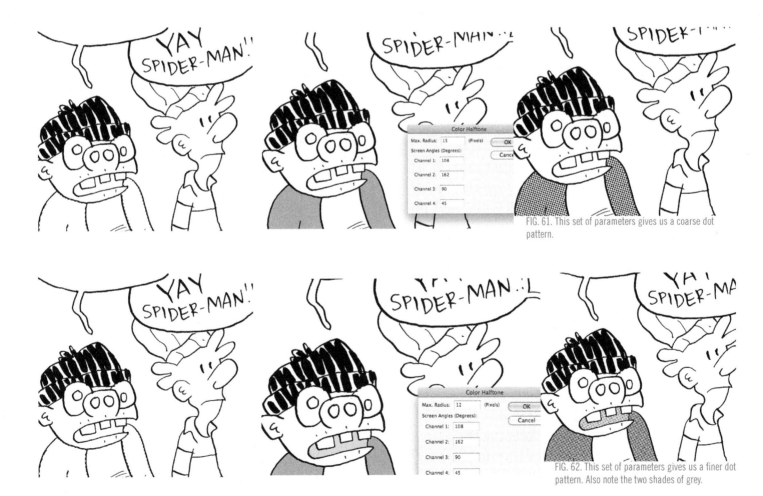

FIG. 61. This set of parameters gives us a coarse dot pattern.

FIG. 62. This set of parameters gives us a finer dot pattern. Also note the two shades of grey.

Lettering

Lettering, like everything else in a comic strip, needs to be clear and appealing. Clarity here can not be overemphasized.

There are any number of reason why lettering is unclear:

- Too sloppy
- Too small
- Too scrunched together
- Holes in letters like O, P, A, etc are too small or closed up (FIG. 69.)
- Not enough space around lettering to breathe inside balloon (FIG. 63.)
- Space between the lines too small or even too large

Good rules of thumb:

- Treat letters like drawings. Each letter takes a number of strokes to make. Do those slowly and consciously.
- Give an even buffer inside the balloon around the shape of the lettering. Don't get too close to the balloon.
- Use ruled lines. One option is to make a master copy of ruled lines that you can trace on top of each time you letter (See FIG. 65). Many cartoonists use a lightbox which enables them to do this.
- Or better still, use a lettering guide. A lettering guide (the most common being the Ames Lettering Guide, see FIG. 66) will create ruled lines, but more importantly, even spaces between your lines (called *leading*). This creates consistent, readable alignment and space for your lettering.
- Balloons should be a simple shape around your lettering, with a simple pointer leading to the speaker. When you over-complicate these matters, by making your general balloon shape too lopsided or difficult to read, it adds to visual clutter which you do not want. See more about balloons in the next section.
- It's ok to have balloons extend past the borders of a panel border, so long as they do not crowd other panels (see FIG. 71).
- Balloon line thickness and lettering thickness should relate to each other. This doesn't always mean they should be the same. Usually a gentle contrast offers the most readability.
- Find the right typeface for YOUR artwork. Most of the time, this will be done with your hand, but there are computer fonts that can work well, if chosen consciously (more about that next).

FIG. 63. An example of text without enough space to breathe in the balloon.

FIG. 64 The letters here have room to breathe inside the balloon. This is much better.

FIG. 65. A sheet I kept beneath my first penciled drawings. These lines helped me keep my lettering and panel borders straight.

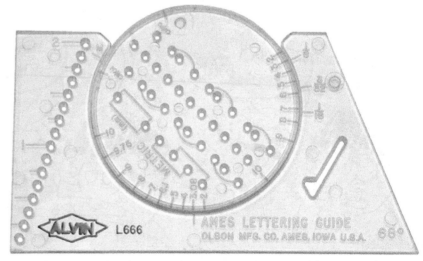

FIG. 66. The AMES Lettering Guide creates evenly spaced ruled lines, complete with space for ascenders and descenders. Look for tutorials online for how to use it!

More Lettering Examples

I WISH I COULD
HAVE A PONY!

I WISH I COULD
HAVE A PONY!

I WISH I COULD
HAVE A PONY!

I WISH I COULD
HAVE A PONY!

I MADE THIS LETTERING
TOO SMALL.

I MADE THIS LETTERING
TOO SMALL.

FIG. 69. Text that will not reduce well.

FIG. 67. Two examples of handwritten text that would reduces to 75% just fine.

TOO MUCH
SPACE
BETWEEN
LINES...

NOT ENOUGH
SPACE BETWEEN
LINES

TOO MUCH SPACE
BETWEEN LETTERS

FIG. 68. Some examples of other problems that can occur in handlettering.

A Word About Word Balloons

Word balloons should really be called word containers, because they need not look like a "balloon" at all. Like most things in comic strips drawing, the main goal is clarity, then appeal. If a balloon clearly does the job of containing the words—dialogue, thoughts, captions—then it can do or look like anything. Word balloons can be rectangular, wobbly or standard, so long as it works with the style of your strip. And if it will be more clear and appealing just free-floating with no container, then that is fine too.

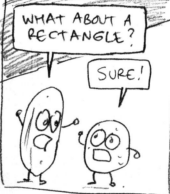
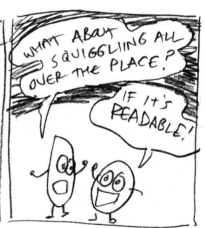

FIG. 70. Balloons that don't look round like balloons.

Additionally, your balloons need not stay contained by the borders of your panel (FIG. 71). Walt Kelly's classic *Pogo* is a great example of a strip that had loads of fun with balloon placement, balloons overflowing giddily into the neighboring panels constantly.

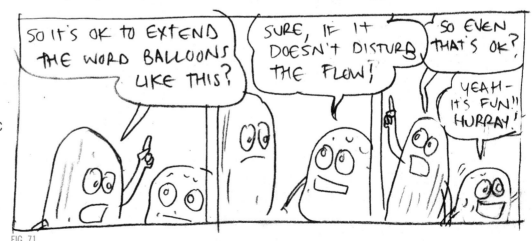

FIG. 71.

Lettering with a Computer

Many cartoonists are choosing to letter with a computer. Computers make the legibility of lettering easy buy many cartoonists sacrifice elegance and style by relying only on the computer's choices. You have to make the choices that are best for your artwork, and your story. A computer can aid you once you've made those choices.

It's important here to emphasize that you should not rely on computers to tell a human story. Your story is a human story. That said, computers are a great tool that can be of use once you've made some human decisions about telling and visualizing your story.

The main decisions we have to make include:
- Choosing a typeface
- Choosing a balloon style
- Spacing between letters, words, and lines

Don't let the computer's default choices here be the choices you make, and don't assume that your only choices are the ones already loaded onto your computer.

Choosing a Typeface

FIG. 72a. Hand-drawn letters and hand-drawn balloon.

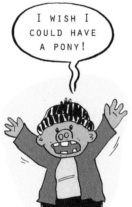

FIG. 72b. Generic computer font in same hand-drawn balloon.

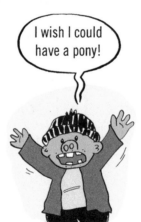

FIG. 72c. The font this book is set in.

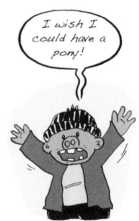

FIG. 72d. Computer font designed to mimic handwriting.

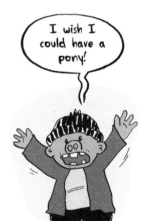

FIG. 72e. This computer font was created from hand-lettering.

FIGs. 72a-72e shows some examples of typeface choices when using a computer: From hand-drawn letters, to standard computer fonts, to fonts designed to mimic hand-lettering, to fonts designed from a hand-drawn typeface by a cartoonist. You'll find your own favorites here, but note that the more mechanical it looks, the more it starts to look like a static image, part of an advertisement maybe, and not part of a smooth readable strip.

The smartest choice you can make is probably *not* choosing a standard computer font. There are hundreds of fonts on the web designed to integrate into cartoon art, and many of them are free. See the bibliography for some current links for those.

Additionally, more and more cartoonists are designing fonts based on their own hand-lettering. This is quite easy and many places online will do this for you cheaply. FIG. 72e shows a font

created from a lettering originally drawn with a no.2 brush. In fact, this font was used for all of the *Ali's House* strips we created.

A good example of using standard computer fonts for effect. Here, the computer transitions from speaking in an ordinary computer voice to a sultry Hollywood-starlet voice. From Shaenon Garrity's *Narbonic*.

Typefaces for Effect

Likewise, if you're using sound effects or some other effect with your text, you want to use the lettering that's right for the effect you want. See FIGs. 73-74 for some examples of how to think about your effect lettering.

FIG. 73a. Duck quacks. Here, a fancy duck, or a mechanical tin duck might sounds like this.

FIG 73b. A definitive duck, perhaps this one is reporting the news.

FIG 73c. No duck quacks in this silly typeface.

FIG. 73d. This feels like a natural duck.

FIG. 74a. An explosion. Here, an odd typeface for an explosion: it seems like a typewriter was dropped from the sky.

FIG. 74b. Very bold, loud, solid. A good choice, though perhaps it could be less straight.

FIG. 74c. Nothing explodes in this frilly typeface. Maybe it's a lace factory.

FIG. 74d. This hand-created font, manipulated for chaotic effect, feels about right.

Computerized Word Balloons

Creating your word balloons on the computer is fraught with the same issues as lettering. The easiest way to do something is not necessarily the clearest or most appealing. It's worth researching our options and studying historical examples before making our choices, and then having the computer assist where it can.

The choices you'll have to make while making your word balloons are:
- Shape of balloon
- Shape of the tail or pointer
- Width of line around both
- Of course, you could also choose no balloon, in which case how you incorporate some sort of pointer from text to characters through empty space becomes another choice to make.

FIG 75a-77 shows some ways of thinking about your computerized word balloons.

FIG. 75a. The most generic computer balloon, a simple oval a triangle combined, then given a fixed-width border or stroke.

FIG. 75b. A balloon hand drawn and given a fixed-width border.

FIG. 75c. A balloon drawn with the Photoshop brush tool, allowing for more line variation.

FIG. 75d. A wobbly balloon but drawn with the elegant pen tool, which allows for smooth curves. A line serves as a simple tail.

FIG. 75e. A clean balloon created with the pen tool in Photoshop, and given a simple fixed width border.

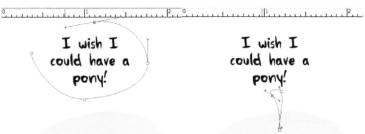

FIG. 76. Demonstration of the Adobe pen tool as it creates shapes by mapping out points and curves. This is the balloon in FIGs. 75e and 75f.

FIG 75f. The balloon in FIG. 75e, filled with a color and left borderless.

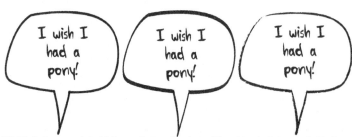

FIG. 77. Balloons created with the pen tool can then have different brush strokes applied to it as a border.

Coloring

The art of coloring a comic strip is a complicated one and many artists will have different approaches. My belief is that *value* is the key to make smart coloring choices that enhance and clarify your strips. Value is the amount of darkness or lightness in a color. Up till now, we've looked only at grayscale values, from white to light grey to dark grey to solid black, and this has prepared us to think in color.

All colors will have degrees of darkness and contrasting these values is one way of making your characters "pop" off the backgrounds. Dark on light is a simple way of creating this contrast, light on dark can work too.

From value (or "lightness" as it's called in computer terminology), you can begin thinking about the other key components in color: hue (also called "hue" on computers) and tint (or "saturation.") In general, contrast, whether it lightness, hue, or saturation is the key to readability with color.

FIG. 78 shows a strip in its initial black and white incarnation. Simple and readable, the black

on the main character's hair and shirt act as anchors and move the eye through the strip. The addition of color in FIG. 79 simply puts some color behind the characters while emphasizing the main characters and especially the prop of the red script. Note in FIG. 80, how when viewed only in grayscale, the colored comic still has a strong contrast of values, allowing the characters to remain readable on their background.

Nothing will change a good overview of color theory, some examples of which are recommended in the bibliography.

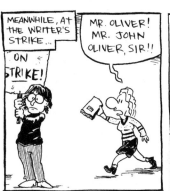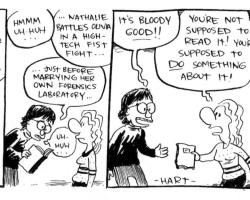

FIG. 78. Original black and white drawing.

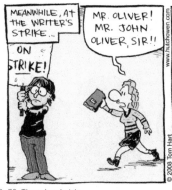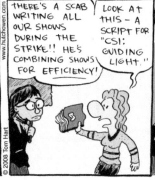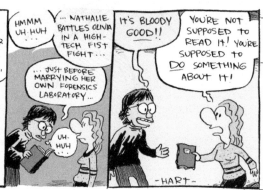

FIG. 79. The colored strip.

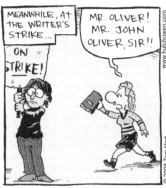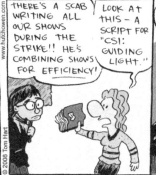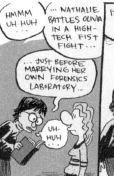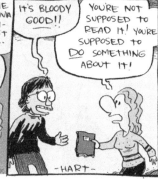

FIG. 80. The colored strip in greyscale.

Computer Coloring

Virtually all comic strip coloring is done on computers these days, mostly with Adobe Photoshop, though there are other software options. It's a simple procedure provided you know what to expect and have given your color choices some thought.

After scanning at a high resolution (at least 800 dpi bitmap or lineart or 600 dpi greyscale—see the bibliography for some more information on this, or search online for scanning tutorials) and adjusting your linework so it looks good and clean, the first point is to set up your file to accept color, by converting to CMYK and adding a couple more layers. I add two layers: one called "fix" where I will put little fixes, closing certain areas and cleaning up the artwork to accept color. This layer will be deleted later so it can be a bit messy. I put it on top of the line art layer. FIG. 81 shows an example of line art without the fixes, and then FIG. 82 shows new black lines on the fix layer and the color that has been added. FIG. 83 shows that color and original line work with the fix layer deleted.

Most cartoonists use the Photoshop magic wand tool to select the areas to be colored, but many use the pen tool and some even use the lasso. What's most comfortable for you is probably fine. There are many, many tutorials online that go into more specifics about coloring for comics.

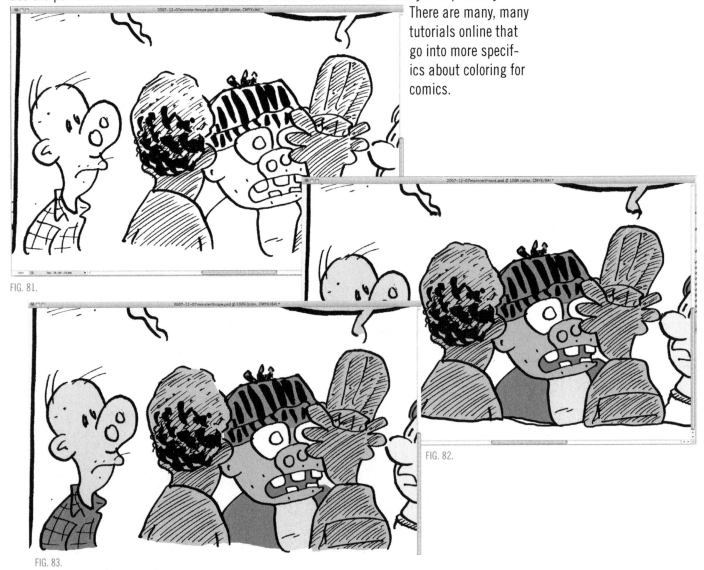

FIG. 81.

FIG. 82.

FIG. 83.

FIG. 84 shows the finished strip, and an example of a *color hold*, an area where a solid color is used to direct the eye to the focal point rather than distracting it with too much detail. This, along with colored balloons, abstract colored backgrounds, color patterns, and other tricks such as colored linework and gentle computer filters, can add to the readability and style of your comic strip.

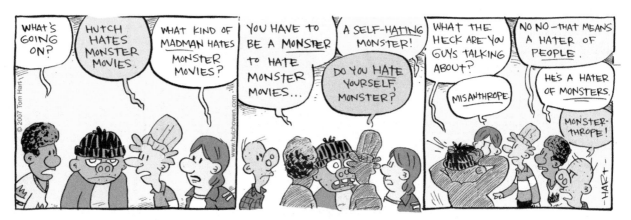

FIG. 84. An example of a color hold, in panels two and three.

The red here helps guide the reader through the strip

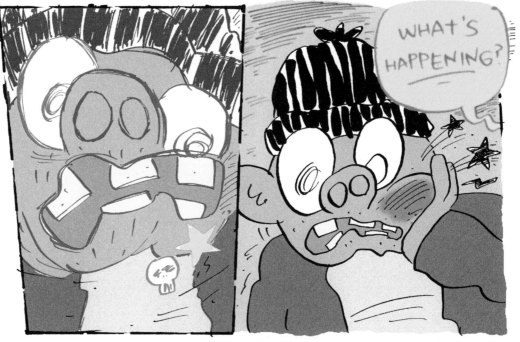

Some computer coloring tricks: coloring the linework, blurring certain sections, adding fades and gradients.

Trapping

If your strip is ever to be printed, which ideally it might be someday, then *trapping* becomes a crucial issue. Since printing in color is done in many layers, your paper will run through the printing press at least 2 but probably 4 times. It is common for the artwork to be ever-so-slightly misaligned. Trapping is a term for making sure your color lies underneath your linework at least far enough so that in these cases of printer misalignment, you won't be stuck with visible ugly white areas in your artwork. (See FIG. 85a.)

To avoid this misalignment, you have to overcompensate by trapping, or by coloring under your linework (or by overlapping adjacent color areas) by a few pixels.

FIGs. 85b-85c shows a selection to be filled, but then that selection expanded to slide underneath the linework. When the pink is filled, you can see how it lies a tiny bit under the linework (FIG. 85c). When printed, this will barely be noticeable, but will ensure your artwork doesn't have those ugly white areas if the printer slips.

FIG. 85a. Just filling in the selection here, which goes right up to the linework, could result in a badly printed edition later, if the printer is misaligned.

FIG. 85b. Instead, moving your selection just inside your linework, will ensure a seamless integration of color and line in print.

FIG. 85c. Here on the left, you can see the overlap of the color and the linework, as well as how it will finally print, even if the printer is misaligned.

Mail-In Assignment: Finished Strips

Finish your 3-5 strips in ink, complete with lettering and if you wish, computer color,
and e-mail them or send photocopies to the SAW headquarters at the address below.

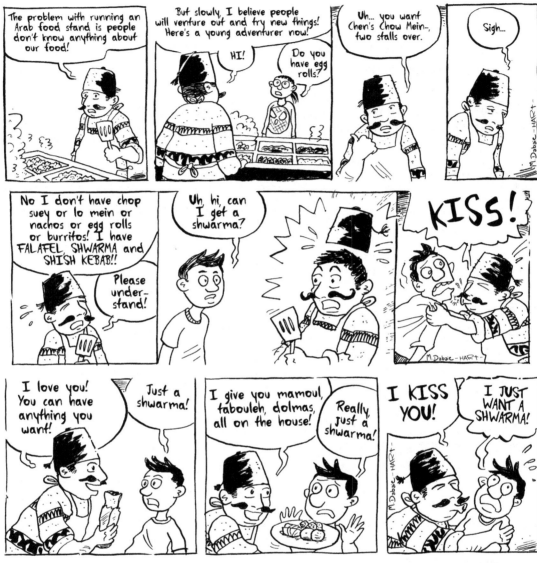

E-mail: thesaw@sequentialartistsworkshop.org
United States Post Office: The SAW, PO Box 13077, Gainesville, FL 32604-1077

Your strips will be returned to you by whichever method you chose.
We'll mark up your printouts or photocopies with critiques and we'll include a
separate sheet with notes and ideas going forward.

Selling a Strip

Selling a strip to a syndicate is something thousands of people try to do each year yet only a small handful actually succeed at. Why?

Partially because there just isn't that much space in newspapers today. Typical newspapers are already running a dozen or so strips and aren't that interested in trying out new ones. Their readers are content and often complain when a favorite strip is dropped for a new untested one. This is not an environment that welcomes many new strips.

Nonetheless, thousands of people each year are drawn to try, because it is such a fun and rewarding medium that allows for a lot of personal expression and satisfaction.

An Editor Speaks

I asked King Features Syndicate editor Brendan Burford some questions about selling a comic strip today.

Question: What are you looking for in a new strip?

Answer: If I knew that a certain execution or approach to making comics was guaranteed to bring success to a cartoonist and, by extension, King Features, I'd certainly point cartoonists in that direction. But it just isn't that simple—the stars really need to align in an often unpredictable way. That said, there are a few things that successful syndicated comic strips have in common, and there are some key things I look for.

Craft: It goes without saying that there are certain tenets to making good comics, and certain skills that require practice and discipline. Without going into specifics (because the landscape is vast and subjective), I do look for competence in clearly communicating with words and pictures.

Connection: Successful comic strips usually reflect our life and times, and our collective sensibilities in some way. A comic strip doesn't have to have such a low common denominator that everyone on earth finds a connection, but readers do gravitate toward strips that say something they can relate to, and the more readers you can reach the more successful you will be. Even if a strip falls into a very specific niche, there are ways to tell universal truths through most niches.

Spirit: A comic strip really needs to be an extension of the cartoonist who creates it. You can't just throw a bunch of premises against the wall and hope that one will capture the popular imagination. If a cartoonist isn't drawing from a well that he/she knows intimately, the ideas will likely fizzle out, and it will become evident that there's no soul behind the thing. Some of the best comics of all time—especially ones that have had a long lifespan—have been very emotionally close to the cartoonist who created them. I can detect a lack of this connection fairly quickly.

Question: Tell us about two strips that you bought recently and what made you believe they were right for your syndicate?

Answer: How about THREE recent comic strips? *Dustin, Oh Brother!* and *Bleeker, the Rechargable Dog*. They're all very different, and each represents a different approach to marketing a new comic strip.

DUSTIN, by Steve Kelley & Jeff Parker: Frankly, signing Steve and Jeff was a no-brainer. *Dustin* fits so well into the American newspaper comics pages, and that is probably the number one reason why I decided to bring it to market. It also doesn't hurt that both Steve and Jeff are staff editorial cartoonists—they have a real feel for what a newspaper reader will respond to. *Dustin* features an authentic American nuclear family, and all of the different dynamics that exist between parents and their living-at-home, recent-college-graduate son. It is expertly written and beautifully drawn—it communicates quickly and humorously, and it displays a certain elegance that is a result of these guys having such a firm grasp of their craft. *Dustin* has been a very big hit, and it's only been around a little over a year.

OH, BROTHER! by Bob Weber, Jr. & Jay Stephens: Bob has been successfully syndicated with King Features for years with his S*lylock Fox & Comics For Kids* feature, and I've always wanted to work with Jay—he's been a personal favorite of mine since his earliest work in the nineties. Bob and Jay are a great team, and balance one another brilliantly. The writing on *Oh Brother!* is simple and funny, and the drawing and color is stunning—it is so much fun to LOOK at this comic. It also has a very easy point of entry—it takes very little to enter the world of these characters and have an immediate sense of where you are. More than anything, though, I decided to bring *Oh Brother!* to market because I thought it had a chance to reach young readers and cross multiple platforms while doing so. At launch, we developed an *Oh Brother!* website that featured the daily comic as well as multiple interactive features for young people. Treating this comic as a cross platform feature has so far been an intelligent decision, and its popularity continues to grow.

BLEEKER, THE RECHARGEABLE DOG by Jonathan Mahood: Jonathan's comic strip had been running online at GoComics for a little over a year before I caught on to it. Jonathan is an incredibly skilled cartoonist, and there's a real charm to his voice—It was quickly evident to me that his comic could grow from a web-only strip, to one that we could sell through multiple outlets, including print newspapers. *Bleeker's* premise is a twist on a very familiar theme—it's about a boy and his pet (*Peaunts, Calvin and Hobbes*, etc.) but very much a reflection of our modern world because *Bleeker* is a robot dog. Jonathan is particularly adept at using the consumer electronics themes that have completely permeated our culture—most importantly, he does it with little to no contrivance, and it's always funny and familiar. Like *Oh Brother!*, I knew it would be important to allow *Bleeker* to benefit from a platform-agnostic approach, and like OH, BROTHER! we prepared a uniquely branded website for *Bleeker* at launch. *Bleeker* just launched a little over a month ago, and we're pleased with its reception.

A Personal History

My own experience with selling a strip may prove useful.

I had been using my cartoon character, Hutch Owen, since around 1994, when I invented him from an imagined version of myself in a 4 page comic story. He then went on to star in a 56-page comic, then a half dozen stories of around 30 pages each. By that point, I realized that I might like to try him in a smaller format, to allow me to use more of the ideas that I had lying around. Previously in all the large-scale stories, I would utilize only a few of the hundreds of ideas I had in my recipe boxes full of index cards. Switching to comic strips would allow me to dip into those ideas more frequently, play with them a little and then move on to something new. It seemed the perfect form for my creative energy, which at the time was overflowing with ideas.

So I switched to comic strips in 2004 using a web-only model to get my feet wet for a year or two before deciding I might like to pitch it as a newspaper strip to the mainstream syndicates.

Having a good sense of history and of what was already out there, I made sure my stories and ideas were newspaper-friendly enough. I took out all the bad words and tried to craft it into an opinionated, but still welcoming strip. At the time, there were plenty of examples of similarly cranky but lovable strips out there: *Doonesbury*, *The Boondocks,* and *Mallard Fillmore* being just a few.

Hutch was a good strip, and I got many kind personal letters back from editors, who across the board responded that though excellent, it was just not the kind of strip they could sell right now.

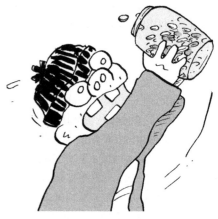

Not being the kind to give up, I found an upstart newspaper in New York and Boston (the daily commuter newspaper *Metro*) who needed a comic strip, and offered my strip to them. It ran in the Boston and New York *Metro* on a Monday-Friday basis for a year and a half before the last in a large number of editorial changes resulted in them canceling my strip and then any strip at all.

In that time, I continued to send packages to the syndicates, getting the same responses as before. One editor said regarding newspaper audiences, "It's like 1963 out there, and very hard to get something more up to date in there."

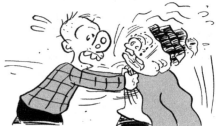

I stopped running *Hutch Owen* as a strip with its ending in *Metro*, and directed my sights elsewhere.

Soon after, I thought that what might be more family-friendly, timely, and welcoming might be a strip based on some of the adventures my cartooning colleague Margo Dabaie had been detailing in some of her autobiographical comics called *Hookah Girl*. Her stories were about growing up Arab-American in California in the 80s. I called her on the phone and suggested we collaborate on a more mainstream comic strip version. She agreed and we had two weeks of strips written and sketched up within a couple of weeks.

To our surprise, we had an editor tentatively agree to buy it if we inked those samples and offered him a few more weeks of finished ideas and penciled strips.

We did that and within a few weeks had a contract in the works. Though we knew we had a great product, we were quite surprised—remember the average syndicate gets thousands of submissions a year and only takes around 4 or 5! We were quite happy. Our editor was happy too. This was a good strip, and a chance to maybe push the envelope a little of what had been previously seen on newspaper pages. He and we thought the world was ready for our friendly strip "about family and falafel."

The next 8 or 9 months was spent "developing" the strip. That is, building up a store of a couple hundred finished strips and working with the editor-in-chief to make sure that they're on target, saying what they need to say, and that they are working to their own advantage to build an audience.

We were just around the end of this process, in the fall of 2008, when the stock market took its biggest dive in decades, and the rate of newspaper failures grew to a new peak. Nonetheless, the syndicate and we launched our strip, *Ali's House* a few months later.

In that atmosphere, with a strip that was a bit weird and unlike others, it proved to be too hard for the sales staff to sell *Ali's House*. In addition, newspapers were asking to pay less for their usual offerings. It was not a good time for newspaper strips.

So in the end, *Ali's House,* having not signed on enough newspaper editors to justify continuing it at the syndicate, returned to us, its creators. Margo and I as of this writing are planning on self-syndicating it in some manner, and are working on our marketing plan.

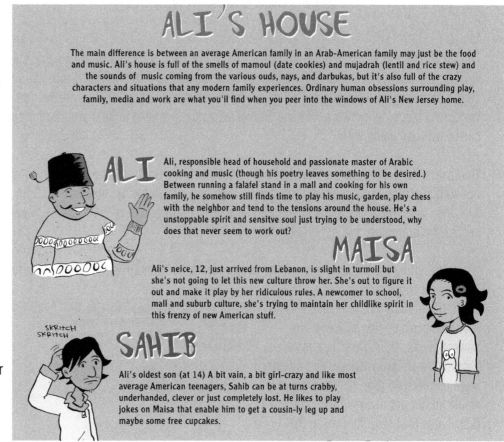

ALI'S HOUSE

The main difference is between an average American family in an Arab-American family may just be the food and music. Ali's house is full of the smells of mamoul (date cookies) and mujadrah (lentil and rice stew) and the sounds of music coming from the various ouds, nays, and darbukas, but it's also full of the crazy characters and situations that any modern family experiences. Ordinary human obsessions surrounding play, family, media and work are what you'll find when you peer into the windows of Ali's New Jersey home.

ALI

Ali, responsible head of household and passionate master of Arabic cooking and music (though his poetry leaves something to be desired.) Between running a falafel stand in a mall and cooking for his own family, he somehow still finds time to play his music, garden, play chess with the neighbor and tend to the tensions around the house. He's a unstoppable spirit and sensitve soul just trying to be understood, why does that never seem to work out?

MAISA

Ali's niece, 12, just arrived from Lebanon, is slight in turmoil but she's not going to let this new culture throw her. She's out to figure it out and make it play by her ridiculous rules. A newcomer to school, mall and suburb culture, she's trying to maintain her childlike spirit in this frenzy of new American stuff.

SKRITCH
SKRITCH

SAHIB

Ali's oldest son (at 14) A bit vain, a bit girl-crazy and like most average American teenagers, Sahib can be at turns crabby, underhanded, clever or just completely lost. He likes to play jokes on Maisa that enable him to get a cousin-ly leg up and maybe some free cupcakes.

Going Your Own Way

Even though selling to the syndicates is hard, it's a dream come true for many. For people deterred by the mainstream newspaper route, there are other options, especially on the web. Indeed, for many, now is the time to create your own opportunities beyond the traditional mainstream routes.

The web shows many creators who have found a following online. From gamer strips like *PVP* to manga-inspired strips like *Questionable Content*, increasingly young adults are going to the web to find strips that appeal to them. Kate Beaton's *Hark, A Vagrant* (www.harkavagrant.com) is one that cracks jokes for educated readers and history buffs and reaches a huge audience not represented by the traditional syndicates. Beaton's comic is a modern success story.

Using the Web

This material changes so often that it needs to be updated every month or two. Prior to this writing, you might have seen other sites like Keenspace, DrunkDuck, WebComicsNation and others providing the best hosting solutions, but right now, in early 2011, it seems that using Wordpress blogging software with the ComicPress plug in seems to be a standard many cartoonists are going with.

Wordpress/ComicPress offers the ability to update on any schedule, and provides a clean navigation structure for readers that is malleable and adaptable by the creators. Both are free once you have a hosting account, and both offer comprehensive instructions, a gallery of successful examples, and useful help forums.

It's worth noting that some creators who have success in the mainstream are opting for web-delivery for some of their less mainstream material. One such creator is Rina Piccolo of *Tina's Groove*. Her newest series, *Velia, Dear*, is a more personal, more story-driven, and slightly more risqué strip than the syndicates would let her get away with. So she distributes that strip for free on the web, gather a following outside of the usual newspaper readership.

Since web-distribution changes so frequently, it's worth searching for the most current models out there. The best thing is to look at inspiring strips and utilize the avenues they've used.

Marketing on the Web

It's a sad truth that even with big companies behind them, most artists are relied on to market their own materials. Today this means lots and lots of social networking on Facebook, Twitter, etc., but next year it could mean something else. It also means finding the places and media sources who will want to talk about your work and then helping them do so. Targeting audiences, finding niches, and getting in front of the relevant readers. This is generally not easy, especially when you'd rather be writing and drawing your strip. Nonetheless, it's part of the whole package of selling a strip, either online or with a syndicate, and it's worth investigating. Some relevant links and books are recommended in the bibliography.

Break the Rules!

A lot of the accepted practices of mainstream comics are rules meant to be broken! If you're going your own way, and not going the newspaper/syndication route, you may find that there are other models out there for creating great strips.

Diary Strips:

A new genre on the web but not seen in newspapers is the diary comic. Made popular by Vermont Cartoonist Laureate James Kochalka, there are now hundreds of people doing small, 3 or 4 panel comics every single day and sharing them online. In his *American Elf*, Kochalka portrays himself and his wife like an elf, other characters like robots and bears, and each day since the late 90s, he's made a small comic detailing some small moment in his day and posted it at americanelf.com. Those strips can be funny, touching, slightly idiotic, repetitive, but also lyrical and transcendent. Nothing is too small or too personal for Kochalka's daily diary.

Since his initial creation, he has published numerous *American Elf* book collections, and has spawned hundreds of imitators.

This has also proven to be a great way to learn the ins and outs of comic-making. Comics journalist Sarah Glidden taught herself comics in 9 months doing diary comics and then went on to sell a graphic novel for a major publisher in the next year. Her comics can be seen at sarahglidden.com.

Formal Fun:

There are a lot of people having formal fun with comic strips, meaning playing with the way we read comics and making us look at the medium anew.

Garfield Minus Garfield is a series of *Garfield* comics with the dialogue and text of the main character stripped away. What remains is an odd assortment of secondary characters musing mostly to themselves. Garfield's owner Jon, especially comes off as neurotic, lonely and haunted.

Zits is perhaps the most playful mainstream strip when it come to formal fun. They are constantly playing with their readers' expectations by finding new ways to tell a quick story

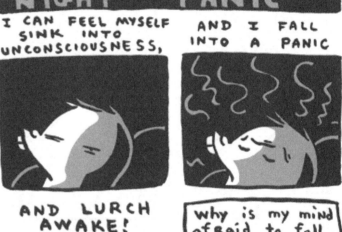

James Kochalka's *American Elf*

or sometimes even confusing their readers for a panel or two before revealing some surprise at the end.

All my rules of line weight and lettering go out the door on the web, so long as you have good writing. *Achewood* (achewood.com) is an example where the stiffness of the characters and lettering adds to the bizarre surrealism of the humor.

Repeated Imagery:

The use of repeated imagery is becoming a bit of a trend, slipping out of the avant-garde and

into mainstream web comics. An early example is filmmaker David Lynch's *Angriest Dog in the World*, in which 4 repeated panels of an angry tied-up suburban dog (the fourth panel being night time) are broken up only by a word balloon coming from a house, usually in the first panel. The text in these balloons is all that ever changed in the 10 years that *Angriest Dog* ran in the *LA Reader*.

David Rees' *My FIghting Technique is Unstoppable*, *Get Your War On* are comics using clip-art of men and women in various poses (office poses for *War*, kung-fu poses for *Fighting Technique*) with dialogue running throughout the strips.

Ryan North's *Dinosaur Comics* at http://www.qwantz.com uses blocky computer lettering and clip-art of dinosaurs fighting to a similar effect.

What these ambitious comics tell us is that comic strips are not supposed to be verisimilitude, they're just supposed to tell us something, make us feel something, show us something. These formally playful examples are all interested in art which communicates ideas, rather than showing us believable scenes based in reality.

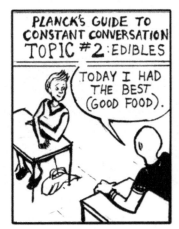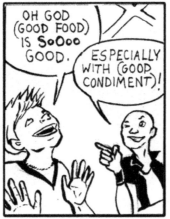

Hilary Allison's *Ha Ha Constance Planck*, using comics not to mimic conversation. but to lampoon it.

Appendix I: The Creation of a Page

What follows is a tutorial of a Sunday-style strip from conception to finished inks. Note that this Sunday strip is not in the particular syndicate-standard measurements, since it ran in a different publication.

THE CREATION OF A PAGE

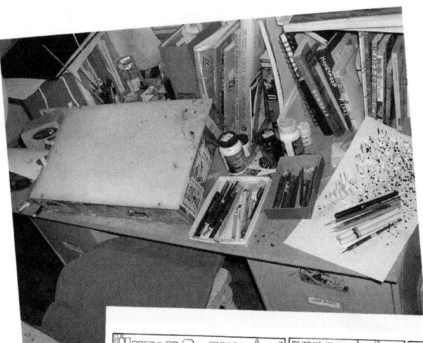

TUTORIAL
AND GUIDE

BY TOM HART

1. INSPIRATION

Inspiration came from the previous strip, where two boys find some recording equipment and interview some of the main characters in the strip. I wanted to explore this further.

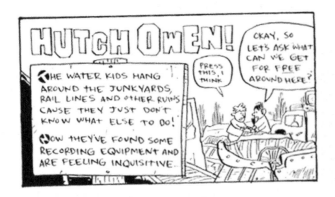

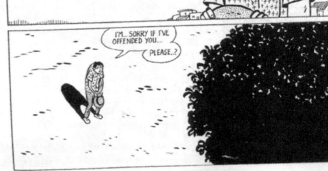

Having read Gilbert Hernandez's Fear of Comics that morning, I was struck by the man posing questions to a tree.

2. SKETCHES AND PLAY

Exploring the idea via doodling and writing.
Questions and lists: What things can you do with a
microphone?

3. DEEPER EXPLORATION AND FIRST PANELS

Playing around with my favorite story structure outlines (a sort of "story circle" or adventure, left) and then imaginative writings (top right) I come to something I am mostly happy with. I begin drawing panels down below (see numbered 1-7 and 8 and 9 on the previous page.)

4. FIRST ROUGHS

Roughed on pre-printed copy paper using red prismacolor pencil. Mostly looking for compositions and gestures.

5. SECOND ROUND OF ROUGHS

Traced up on a lightbox with a mechanical pencil on
pre-printed copy paer.

Still exploring solutions and ideas.

6. RESEARCH AND POSES

54 Falling

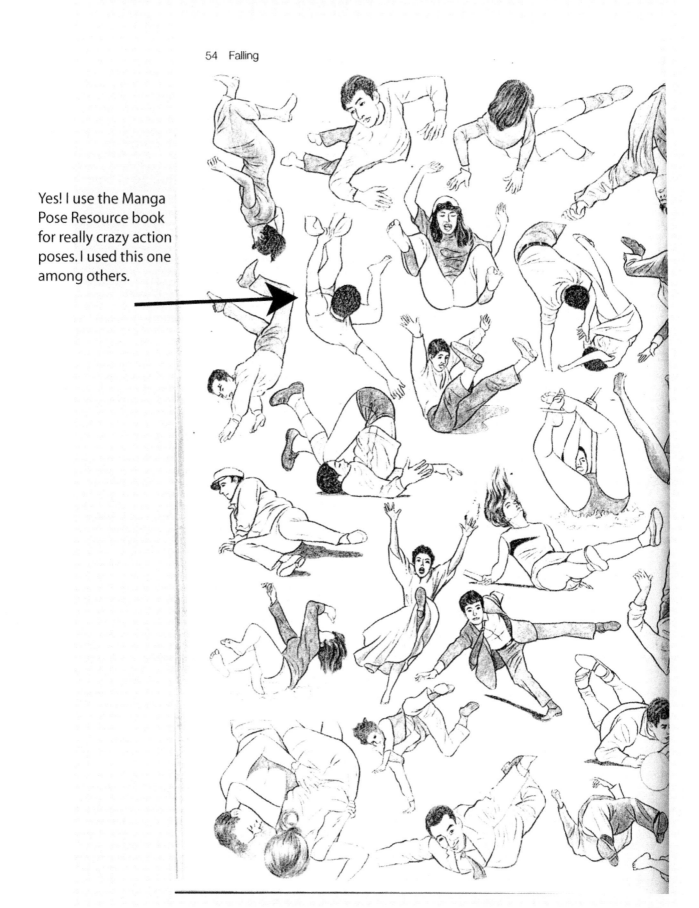

Yes! I use the Manga Pose Resource book for really crazy action poses. I used this one among others.

7. VISUAL RESEARCH

CIGAR STORE INDIANS

From a book on costumes I drew some "cigar store Indians" and from Google Images, I sketched some rats. (I was never pleased with my rat drawings in this strip...) I also sketched raccoons from a book on drawing animals.

I always sketch in red pencil, cause the waxiness makes for a quick, smooth drawing experience that makes great, pleasing gesture drawings.

8. FIRST PENCILS

Now pencilling on bristol board, using the lightbox to work from the previous drawings.

I focus on the drawings that are easy and fun. The hard ones come later.

AND FINISHED PENCILS

If I get real discouraged I'll start inking before the pencils are done, but this time I didn't...

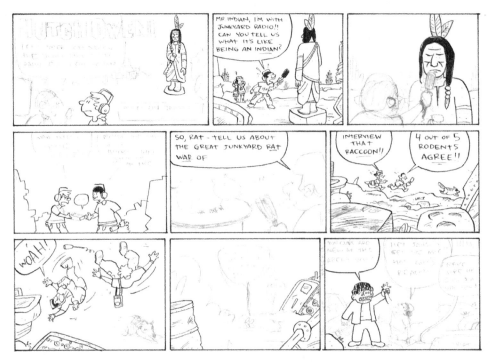

9- INKS!

Just like with the pencils, I ink what I like first, and save the scary stuff for last..

The back view of the kid was the biggest battle on this page and took ages to get right in the inks.

I also think I might have overdone some of the hatching..

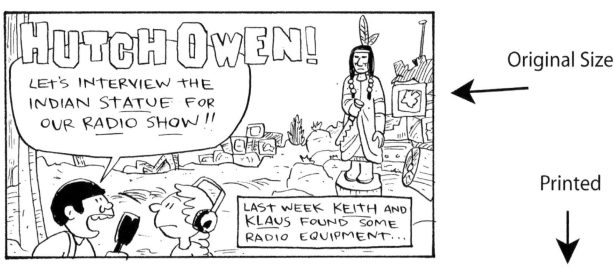

Original Size

Printed

Pens Used

Gillotts 850 for 90% of the inking
Kohinoor Rapidograph Size .3 for details
Kohinoor Rapidograph Size 1.2 for outlines
Sakura Brush Pen for blacks

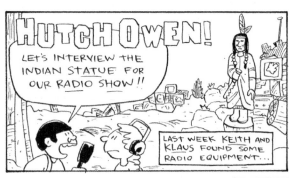

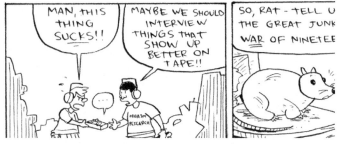

10. FINAL INKS:

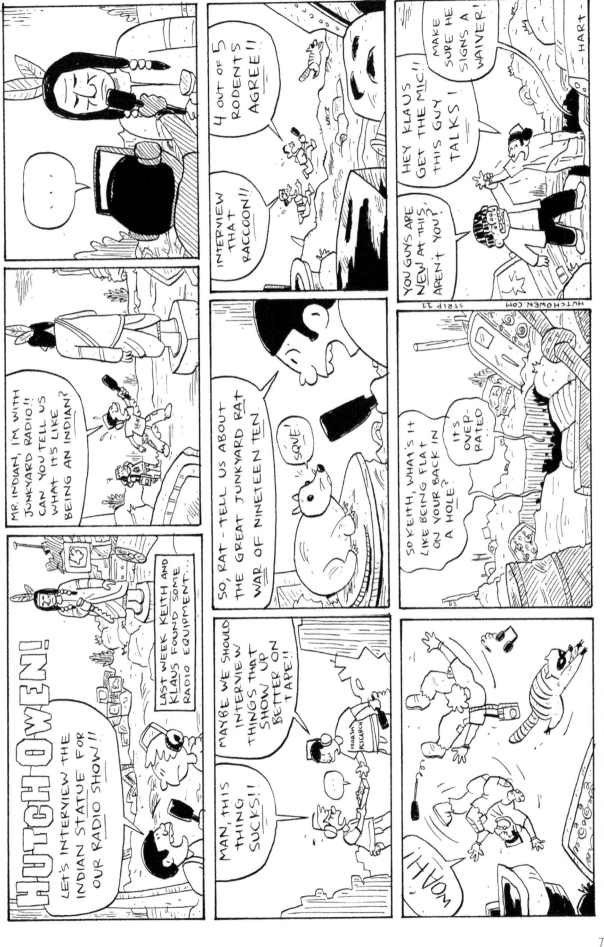

Appendix II: Comic Strip Random Instruction Cards

What follows is a selection of random instruction cards I used to try new things and keep myself doing surprising things. These instructions, or "oblique strategies" as they've been coined by Brian Eno and Peter Schmidt, are designed to be pulled out one at a time, to stimulate creative problem solving.

- no difference between panel 3 and 4
- panel 3: a new character walks in.
- one box is all words
- 4th panel: report back to a new family member
- reality wins out in panel 4
- ask permission to do something already done
- absurd answer to unsolvable problem
- try to write as someone who doesn't love coffee
- all empty panels
- get what you want in panel 4 but work for it
- use a famous folk tale
- the way something feels
- 1 panel or 2
- something you saw on a meta-Garfield site
- more Japanese: less joke, more (development) movement
- compare 2 wildly different things
- panel 4 is much much later
- what is the silent gesticulating person talking about?
- panel 4 disproves panel 3
- the difference between panel 2 and 4
- the (character's) physical limitations make for a bizarre finale
- traditional character tries something traditional with nontraditional materials
- compare AND contrast
- silent visual metaphor
- someone else's visual POV
- action described
- something weird, later contextualized
- everything is off panel
- switch a role
- stretch a character's strength (or weakness) and call him/her on it
- keep characters not on the same page
- funny picture for negative emotion
- beg (or get cocky) for something you don't get in panel 4
- announce the climax early on
- what can you censor?

Bibliography

General Comic Strip History and Overview
Blackbeard, Craine and Vance: *100 Years of Comic Strips*
Walker, Brian: *Comics Before 1945*
Walker, Brian: *Comics Since 1945*
Walker, Mort: *Behind the Scenes at the Strips*
Various: *The Smithsonian Book of American Comic Strips*

Comic Strip Techinque
Abel, Jessica and Madden, Matt: *Drawing Words and Writing Pictures*
McCloud, Scott: *Understanding Comics*
McCloud, Scott: *Making Comics*
Brunetti, Ivan: *Cartooning Philosophy and Practice*
Various: *Famous Artists Course in Cartooning* (search online for this.)

Drawing and Composition
Blair, Preston: *Drawing for Cartoon Animation*
Edwards, Betty: *Drawing from the Right Side of the Brain*
Gollwitzer , Gerhard: *The Joy of Drawing*
Hamm, Jack: *Drawing the Head and Figure*
Hamm, Jack: *Cartooning the Head and Figure*
Hamm, Jack: *Drawing Scenery: Landscapes and Seascapes*
Krause, Jim: *Design Basics Index*
Nicolaides, Kimon: *The Natural Way To Draw*
Online:
John Kricfalusi's blog: johnkstuff.blogspot.com

Lettering
Spiekermann, Erik and Ginger, E.M.: *Stop Stealing Sheep (and Learn How Type Works)*
James Craig, Bevington and Scala: *Designing with Type: The Essential Guide to Typography*
Online:
http://www.balloontales.com/tips/index.html?type=lettering - Tips for making good digital balloons and special effect stuff from the talent of ComicCraft also some points on font usage.
http://www.blambot.com - A good source for fonts and information about using fonts.
http://www.yourfonts.com - An easy to use generator for creating a font of your own handletterring.
Film:
Helvetica documentary
Typomania short film

Color
Albers, Josef: *Interaction of Color*
Itten, Johannes: *The Art of Color*
Online:
Search for coloring tutorials. Recommended: Tutorials by Dave Cooper, Jason Little and Kazu.

Writing

Atchity, Kenneth: *A Writer's Time*
Bradbury, Ray: *Zen in the Art of Writing*
Elbow, Peter: *Writing Without Teachers*
Gardner, John: *The Art of Fiction*
Goldberg, Nathalie: *Writing Down the Bones*
Kundera, Milan: *The Art of the Novel*

Foiling the Critical Mind and General Creativity

Arden, Paul: *It's Not How Good You Are, It's How Good You Want To Be*
Barry, Lynda: *What It Is*
Eno, Brian: *A Year ... With Swollen Appendices*
Hart, Tom: *How to Say Everything*
Johnson, Steven Berlin: *Where Good Ideas Come From: The Natural History Of Innovation*
Johnstone, Keith: *Impro*
Maisel , Eric: *Fearless Creating*
Young, James Webb: *A Technique for Producing Ideas*

Comics Mentioned in the Guide:

Allison, Hilary: *Ha Ha Constance Planck*; hilaryallison.com
Dabaie, Margot and Hart, Tom: *Ali's House*; alishouse.com
Garrity, Shaenon: *Narbonic*; narbonic.com
Hart, Tom: *Hutch Owen*; hutchowen.com
Kochalka, James: *American Elf*; americanelf.com
Laban, Terry and Patty: *Edge City*; edgecitycomics.com
Mannheim, Stephanie: *Roxie, Nate the Non-Conformist*; stephaniemannheim.com
Piccolo, Rina: *Tina's Groove*; dailyink.com
Piccolo, Rina: *Velia, Dear*; rinapiccolo.com

Learn More at SAW

This book is created in conjunction with The Sequential Artists Workshop, a comics and graphic novel school in Gainesville, Florida.

We are offering counseling, mentoring, and critiques of exercises in this book through our online component. We invite you to check us out at sequentialartistsworkshop.org for more on our on-line courses and publications, as well as services such as online tutoring, editing, and advising.

You can read what our previous satisfied students have written, and see what we are up to at our blog at sequentialartistsworkshop.org.

Thanks for reading and good luck!

CPSIA information can be obtained
at www.ICGtesting.com
Printed in the USA
LVOW02s0852220716

497371LV00006B/11/P